THEN *&* NOW

ELLICOTT CITY

THEN & NOW

ELLICOTT CITY

Janet Kusterer and
Victoria Goeller

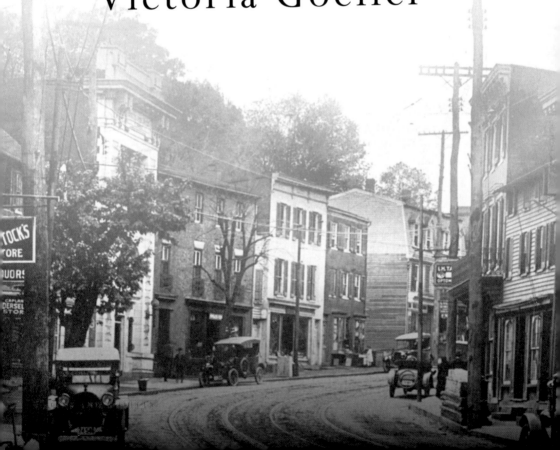

For George, my love, and Joe, my son.
—VG

For Tom, my support and inspiration,
and Dave and Rob, who keep things interesting.
—JK

Copyright © 2006 by Janet Kusterer and Victoria Goeller
ISBN 978-0-7385-4309-3

Library of Congress control number: 2006926316

Published by Arcadia Publishing
Charleston SC, Chicago IL, Portsmouth NH, San Francisco CA

Printed in the United States of America

For all general information contact Arcadia Publishing at:
Telephone 843-853-2070
Fax 843-853-0044
E-mail sales@arcadiapublishing.com
For customer service and orders:
Toll-Free 1-888-313-2665

Visit us on the Internet at www.arcadiapublishing.com

On the Front Cover: The Ellicott City Baltimore and Ohio Railroad Station is the oldest railroad terminus in the United States. Built in 1831, it sits at the end of the first 13 miles of track laid from Baltimore, the Old Main Line. It is on the National Register of Historic Places and is now a living history museum. (Then image courtesy of Charlotte Holland; now image courtesy of Victoria Goeller. Throughout the book, all images courtesy of Victoria Goeller unless otherwise noted.)

On the Back Cover: The Oliver Viaduct was built in 1829 to carry the railroad tracks over Main Street. Two of the three arches were replaced in the early 20th century to accommodate street traffic. (Image courtesy of Herb Johl.)

CONTENTS

ACKNOWLEDGMENTS

From Victoria Goeller:
Many people contributed in many ways to the completion of this book. First and foremost, I thank my husband, George, for his love and gift of time; Janet Kusterer, the wizard of words, my partner, friend, and the steady stalwart of this project; and Ken Lurie, Michel Tersiguel, and Team Tersiguel, for indulging me as they often do.

From Janet Kusterer:
Thanks to Vickie Goeller, who has been the best working partner anyone could wish for, who anticipates needs and seamlessly supplies them, who fearlessly climbed all the seven hills of Ellicott City in search of the best photographs and matching angles, and who made this so much fun. Thanks to my husband, Tom, the best listener in the world, who helped me stay the course, and thanks to my friend Tom Sheehan, who shared his wisdom and support whenever I needed it.

From both of us:
Thanks to so many friends who shared their photographs, time, talent, knowledge, and love of Ellicott City. We greatly appreciate the support of the Ellicott City Restoration Foundation; Adele Air; David Ennis; Scott Habicht; John and Shelley Harris; Charlotte Holland and the legacy of her mother, author Celia Holland; Barry and Nancy Gibson; Betty Jacobs; Herb Johl; Earl Klemm; Dee Dee Lancelotta; Ed Lilley; Paul and Valerie Miller; Ned Rogers; Ann Ryder; Marvin Sachs; Charles Wagandt; Bessie Walter; and Ed Williams. Finally we acknowledge the contributions, through their work, of Ellicott City scholars and authors Joetta Cramm and B. H. Shipley Jr.

References
Cramm, Joetta. *Historic Ellicott City: A Walking Tour*. Woodbine, MD: K&D Limited, Inc., 1996.
———. *Howard County: A Pictorial History*. Norfolk, VA: The Donning Company, 1987.
Evans, Charles Worthington, Martha Ellicott Tyson, and G. Hunter Bartlett. *American Family History: Fox, Ellicott, Evans*. Cockeysville, MD: Fox, Ellicott, Evans Fund, 1976.
Feaga, Barbara W., et al. *Howard's Roads to the Past*. Ellicott City: Howard County Sesquicentennial Committee, 2001.
Harlowe, Jerry L. *Mile Markers of the Baltimore and Frederick-Town Turnpike Road*. Catonsville, MD: Merrifield Graphics and Publishing Service, Inc., 2005.
Holland, Celia M., Janet P. Kusterer, and Charlotte Holland. *Ellicott City, Maryland: Mill Town, USA*. Ellicott City: Historic Ellicott City, Inc., 2003.
Kusterer, Janet P., Travis Harry, and Charles Kyler. *The Ellicott City B&O Railroad Station Museum*. Ellicott City: Historic Ellicott City, Inc., 2005.
Sharp, Henry K. *The Patapsco River Valley*. Baltimore, MD: Maryland Historical Society, 2001.
Shipley, B. H. Jr. *Remembrances of Passing Days*. Virginia Beach, VA: The Donning Company, 1997.
Travers, Paul J. *The Patapsco: Baltimore's River of History*. Centerville, MD: Tidewater Publishers, 1990.

INTRODUCTION

From Baltimore's great A. Aubrey Bodine to a child with a Kodak Brownie camera, Ellicott City has always captivated photographers. Its cabins, castles, rivers, and rails are a delight to the eye. Much of the history of Ellicott City has been captured through a lens, as for over a century photographers have documented growth, loss, and renewal—be it the lengthy restoration of the oldest railroad station in America or the swift devastation of the Main Street fire of 1999.

Professional photographers produce postcards that travel around the world, displaying our granite and grit. Amateurs document snapshots of our daily lives, from the fanciful bubble-blower on the corner to the artfully arranged flowers in front of the oldest market on Main Street. These scenes, treasured by residents and visitors alike, are a visual history of the mill town. They can be found in family photograph albums, personal and public collections, on the Internet, and in antique shops near and far.

Although much has changed over time, little of the landscape and style of Ellicott City has been substantially altered. The "bones" of the original architecture are there for the observer, as can be seen in many of the "then and now" photographs that fill this book. These images tell the story of our small but significant mill town.

In the 1760s, John, Joseph, and Andrew Ellicott traveled throughout Pennsylvania and Maryland searching for the perfect place to build their mill. The Ellicott brothers were millers from Bucks County, Pennsylvania. They needed land to grow wheat and a river to power a mill to grind the wheat into flour. They found the perfect site and purchased the land on either side of the Patapsco River, 11 miles west of Baltimore, Maryland. The first flour to be milled in the Ellicotts' new mill in 1774 came from the Ellicotts' own land.

Gradually the brothers convinced local farmers to grow wheat instead of tobacco. They taught farmers how to enhance the depleted soil with plaster of paris and so kept the population here, stopping the westward exodus that had occurred when the soil could no longer be farmed. As the supply of wheat increased, the Ellicotts began exporting their flour to England. To ease the shipment of flour, the brothers—with the backing of Charles Carroll of Carrollton, one of the signers of the Declaration of Independence—constructed roads east to Baltimore and west to Cumberland. This became part of the National Road.

As the Ellicotts prospered, so did the town of Ellicott's Mills. Churches and schools were constructed, many on land donated by the Ellicotts. The railroad came and the first terminal was built. Construction boomed—from modest homes for the mill workers to mansions for the wealthy who escaped the heat of Baltimore summers by traveling on the train to this new enclave.

In the 19th century, Confederate president Jefferson Davis's daughter went to school in Ellicott City, as did Wallis Warfield Simpson's mother—both to the highly rated Patapsco Female Institute, where young ladies were given an unusual education for the time, one including science and mathematics in addition to manners and other social skills. Babe Ruth married here for the first time, at the beginning of his legendary baseball career, at the age of 19. Newspaperman and wry observer of local life H. L. Mencken spent summers relaxing and regrouping with friends on Church Road.

The railroad was the major link with the rest of the world, and local people used it to commute to jobs in Washington, D.C., and Baltimore, while those residents escaped the cities' heat and retired to the ministrations of Ellicott City's Howard House or Disney's Tavern, where meals and lodging could be enjoyed, perhaps while waiting to attend to legal matters up the hill at the courthouse.

By the time World War II arrived, Ellicott City was the hub of activity for Howard County. Surrounded by farmland, it provided the amenities sought by farmers coming to town on weekends. Here they could get haircuts, see a movie, buy groceries and furniture, and meet up with friends at a local eatery. The nearby Patapsco River provided fishing opportunities in the summer and an ice-skating venue in the winter months.

The river wasn't always a benign presence, however, and continues to be a force to respect. Periodically heavy rains swell the river, and it overruns its banks, wreaking havoc on the town. A marker next to the railroad station indicates that the waters have risen many feet more than once in recent history. One of the most memorable floods—and the one that served to change the course of Ellicott City history—was caused by the destructive Tropical Storm Agnes, which struck in June 1972. As people were preparing for a huge celebration honoring the bicentennial of the town, the relentless storm filled Main Street and beyond with water, mud, and debris.

This was a pivotal point—a time when the town's citizens had to decide whether to rebuild or relocate. At the same time, a gradual transition had been taking place, which was moving the town into its next chapter. The new shopping malls being built along Route 40 in the late 1950s and early 1960s were drawing businesses like grocery stores and car dealerships away from the downtown area. In 1962, the Old Line Shop opened on Main Street—an antique shop that accurately predicted the direction the town would take. From being a practical center of commerce, the town evolved into a village filled with attractive shops and restaurants—no chain stores here—interesting art galleries, and well-restored historic sites. In 1974, the Howard County Council designated Ellicott City as the first officially recognized historic district, and it was listed on the National Register of Historic Places in 1978.

Over the years, movies and television have discovered the location as well and used the local scenery to advantage. In the 1950s, the movie *The Goddess* filmed scenes on Main Street, much to the delight of the locals. In the 1990s, the popular television show *Homicide* left its usual Baltimore locale to film here as well. Unsuspecting onlookers were amazed at the number of police officers to be found on the street at that time, not realizing that they were actors.

Ellicott City has gone from a utilitarian town to a tourist destination in a few short generations, and its evolution continues. Thanks to contributions by preservation groups like Historic Ellicott City, Inc.; the Ellicott City Restoration Foundation; the Howard County Historical Society; the Ellicott City Consortium; and the Howard County Department of Recreation and Parks, the town's historic sites are well preserved and offer a wealth of information to visitors. Unique shops offering antiques, original art, crafts, and collectables abound. Restaurants in buildings that once served as anything from a stable to a hardware store to the mayor's dental office offer special ambience along with their cuisine. And of course there are the ghosts. A town this old, one that saw activity during the Civil War, has to have some stories to tell, and it does. A walk down Main Street with someone in the know will leave even the most skeptical a believer. Our hope is that this book will entice you to see and enjoy this wonderful town yourself—compare what was to what is—and, of course, take a few photographs.

ROADS, RAILS, AND THE RIVER

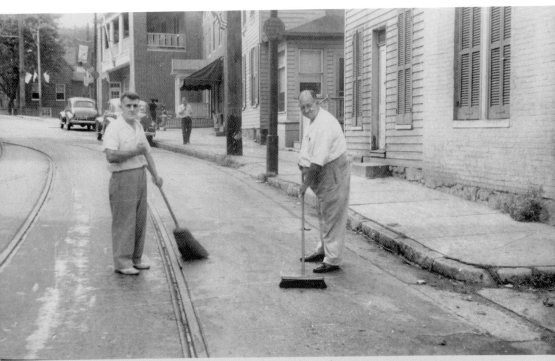

for Parade 1942

Ellicott City exists because of the convergence of the National Road, the Old Main Line of the railroad, and the Patapsco River. Road and rails were means to get crops to market and move people and merchandise quickly and efficiently. The river provided the power to run the mills and make the area a premier industrial center in the 19th century. Here fire chief B. H. Shipley (right) and E. Reid Bossom sweep up in preparation for the 1942 Decoration Day Parade. (Image courtesy of Shirley Bossom.)

The Ellicotts built a road from Ellicott's Mills five miles west to Doughoregan Manor, home of Charles Carroll of Carrollton, a signer of the Declaration of Independence, to facilitate the transfer of wheat to market. In 1790, they extended that road to Fredericktown, and the road became part of the National Road, created while Thomas Jefferson was president. Stone mile markers noted the distance to Baltimore. Today Main Street is also recognized as a Scenic Byway. (Then image courtesy of Genie Sachs.)

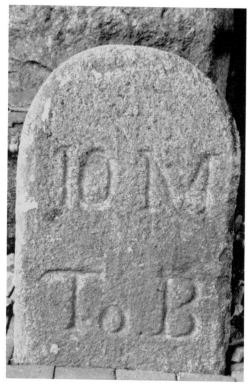

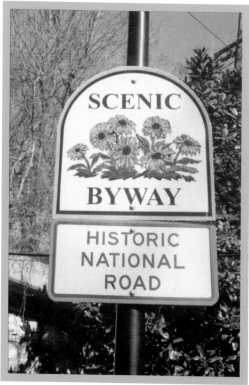

ROADS, RAILS, AND THE RIVER

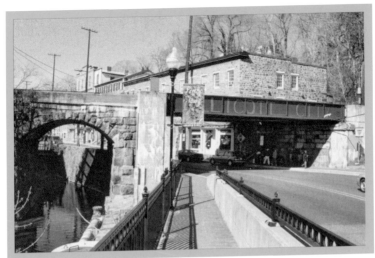

The Oliver Viaduct is the bridge carrying the railroad tracks over Main Street. It was built in 1829 and originally consisted of three stone arches. Two were removed around 1900 to improve traffic flow—trolleys had difficulty maneuvering around them. They were replaced with a steel span, and the remaining arch spans the Tiber River. In 2003, a group of Howard County firefighters painted the span to welcome visitors to the historic district. (Then image courtesy of Herb Johl.)

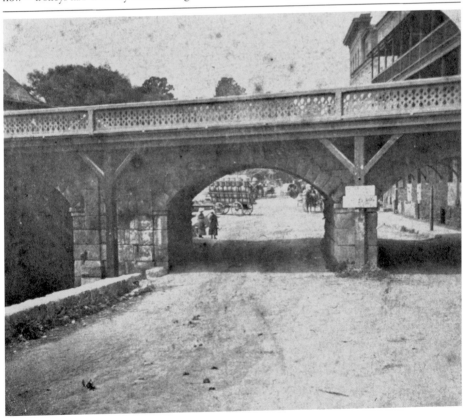

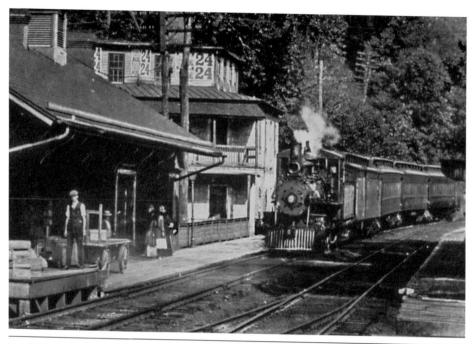

The Ellicott City Baltimore and Ohio Railroad Station was the first terminus of the Baltimore and Ohio Railroad (B&O), completed in 1831 on land donated by the Ellicott family. It stopped accommodating passengers in 1949 and closed after Tropical Storm Agnes in 1972. It was declared a National Historic Building in 1968 and was restored and opened as a living history museum by Historic Ellicott City, Inc., in 1976. Programming includes "Roads to Rails" and a holiday model train exhibit. (Then image courtesy of Herb Johl.)

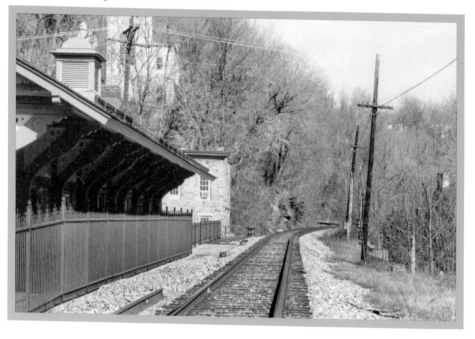

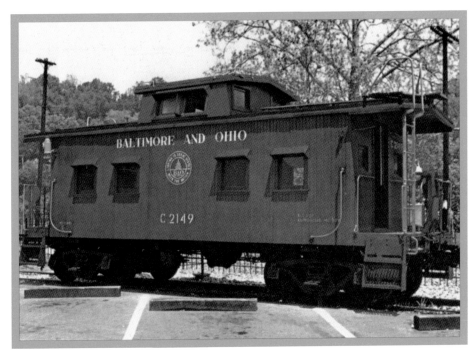

The caboose on permanent display next to the Freight House at the Ellicott City B&O Railroad Station Museum was built in 1927. It is approximately 33 feet long and almost 10 feet wide. It has a concrete floor for added weight to assist in pushing trains. It arrived on February 14, 1974, a gift from the Chessie system. Originally yellow, it was restored and painted red. A second restoration occurred in 2002. (Then and now images courtesy of Herb Johl.)

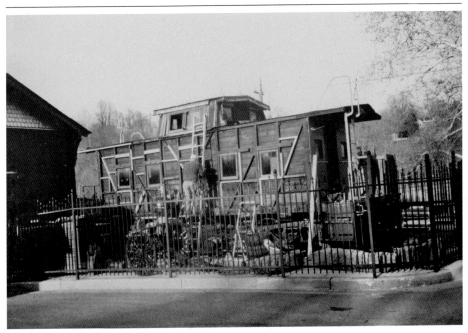

The area in front of the Ellicott City B&O Railroad Station is a focal gathering place. While the station was in use, this was a utilitarian location, bustling with vehicles being loaded and unloaded with goods coming and going by train. Many gatherings were held here as well. In the 19th century, these horsemen stopped here on their way to Gettysburg. In 2006, citizens and reenactors gathered again to celebrate the station, now a museum. (Then image courtesy of Herb Johl.)

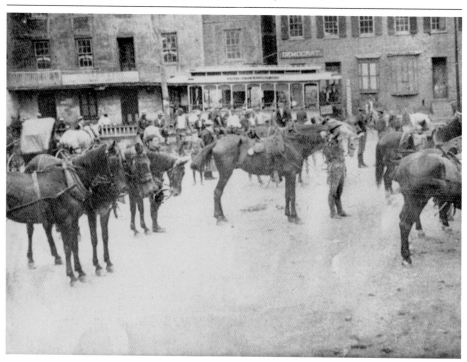

ROADS, RAILS, AND THE RIVER

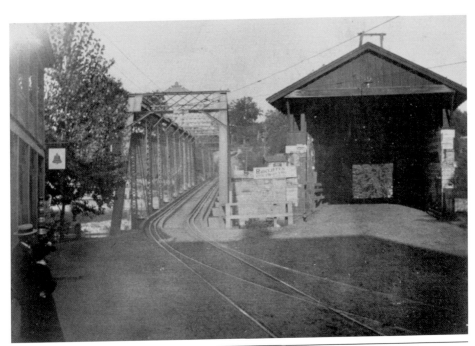

In 1868, the covered bridge over the Patapsco River was destroyed during a flood. A new bridge was constructed in 1870. Beside the trolley bridge, completed in 1899, it accommodated people and goods until June 7, 1914, when a lit cigarette carelessly tossed ignited a gasoline leak, causing the bridge to burst into flames. A concrete bridge built to replace it was lost during Tropical Storm Agnes in 1972. The current bridge was completed in October 1972. (Then image courtesy of Charles Wagandt.)

Following the completion of the main depot of the railroad station in 1831, the area in front of it was often crowded with the carts of farmers bringing crops for transport to Baltimore and the carriages of merchants and citizens picking up goods and passengers from faraway places. In later years, trucks and cars filled the area. Traffic backups were a daily occurrence. The plaza was created in the early 1970s, during the first restoration of the building. (Then image courtesy of Herb Johl; now image courtesy of Scott Habicht.)

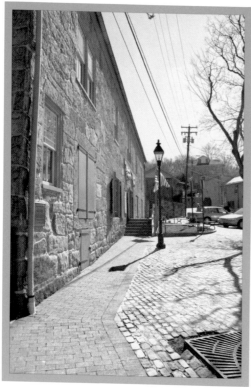

ROADS, RAILS, AND THE RIVER

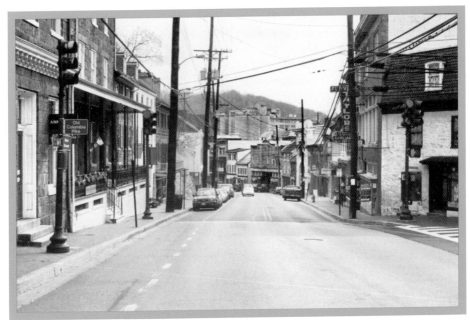

Looking east down Main Street from its junction with Columbia Pike, the vista is little changed over the last century. On the left, the picture illustrates the loss of the fancy ornamental grillwork on the Howard Hotel. The telephone poles were even more intrusive then, but the street still had its share of trees. Today's street scene includes traffic lights and crosswalks as well. At this busy intersection, the pedestrian crossing sign indicates the number of seconds left until the light changes.

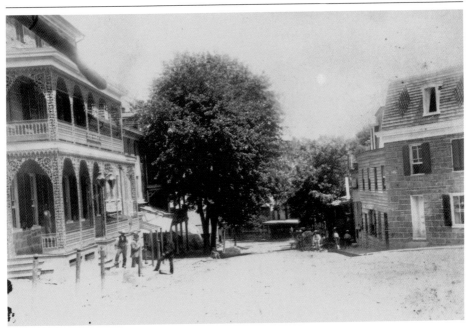

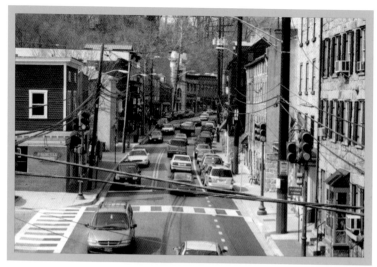

Looking west from the lower end of Main Street, this view shows its intersection with Maryland Avenue. This was the beginning of the National Road, which the Ellicott brothers started to connect to Doughoregan Manor to transport crops to market. The prominent building on the left corner is the Phoenix Emporium, formerly O'Brien's, Fissell's, and Valmas' bars and restaurants. Until the mid-19th century, the lot was used for lumber storage.

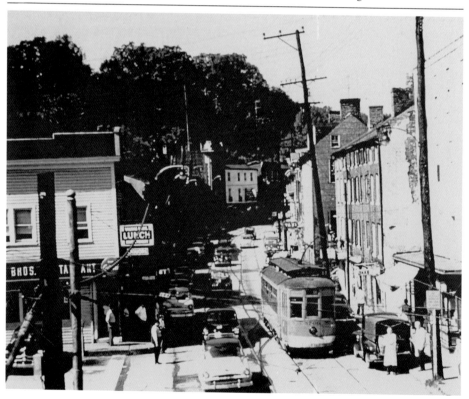

ROADS, RAILS, AND THE RIVER

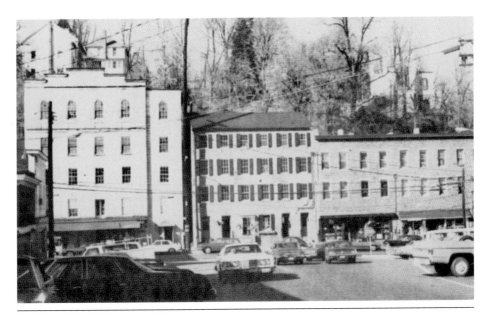

Maryland Avenue is one of the shortest streets in town. It runs about a block, from lower Main Street, in front of the railroad station, to the beginning of St. Paul Street. While short, it is an important connector to St. Paul's Church and the houses up on yet another of the seven hills of Ellicott City. Facing the street is the new town hall, and the rear of the First Lutheran Church can be seen on the hill above it.

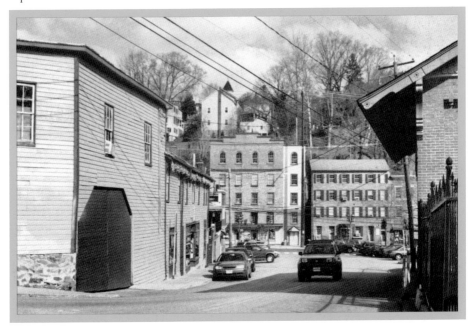

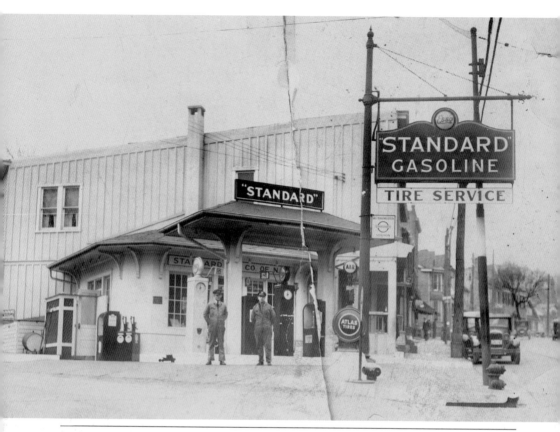

In the 19th century, today's Main Street and Columbia Pike intersection was the major junction of Route 29 and Route 40. These roads have since been developed to the north and south of this location. In the early 20th century, a retail building was demolished to make way for the gasoline station, which was later removed to widen the street. The colorful mural is a local landmark, and the bench in front is a resting point along the steep road. (Then image courtesy of Dee Dee Lancelotta.)

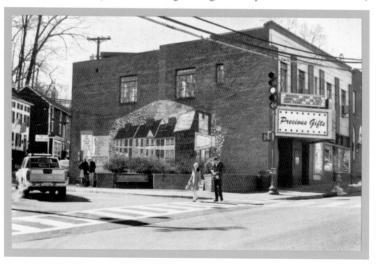

ROADS, RAILS, AND THE RIVER

The Green Cross Garage was on Hamilton Street behind the post office. It was owned by Charles Miller, who also owned the Chevrolet dealership in front of it on Main Street. Later it was a storage facility for Taylor's Furniture. It was destroyed by arson in 1992. The site is currently unimproved, but there are plans to build a mill replica there. (Then image courtesy of Betty Yates Jacobs.)

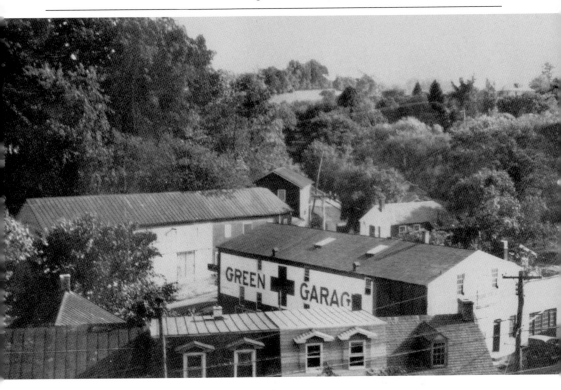

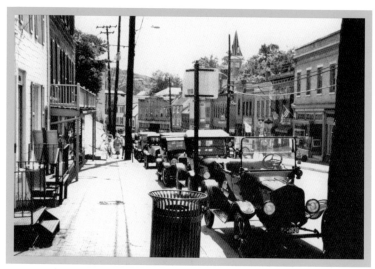

Lovely trees used to line Main Street; now telephone poles do. The early-20th-century photograph also features the wooden water pumps made by Hamilton Oldfield. The H. Oldfield's Pump Works building, which later housed Green Cross Garage, was located behind the current post office. The water pumps and troughs on Main Street were for the horses that brought people to town. Today the town often hosts history buffs, like the owners of the vintage cars in the recent photograph. (Then image courtesy of the Ellicott City Restoration Foundation; now image courtesy of Earl Klemm.)

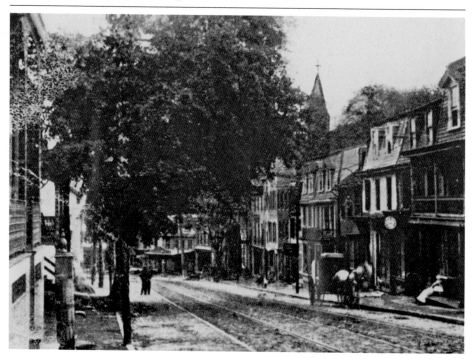

HARDWARE AND ANTIQUES

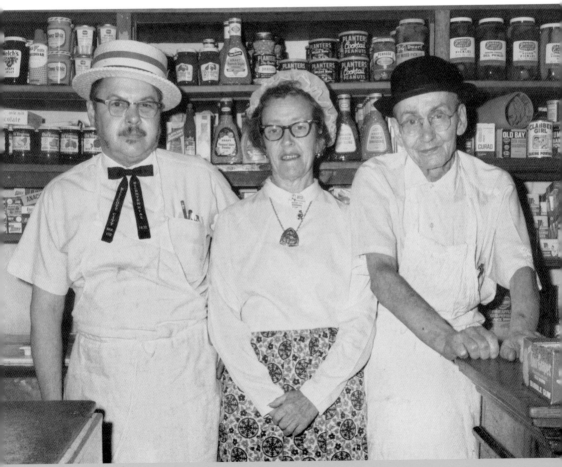

In 1972, Ellicott City merchants were busy planning the bicentennial of the town when they were hit with the devastation of Tropical Storm Agnes. This was a crossroads for the town: to rebuild or pull up stakes and move on. They decided to stay, and just a few months after the hardship of the flooding, they celebrated as planned. Among the celebrants, this photograph shows S. Bladen Yates (left), his wife Dorothea (Ditty) Yates, and his father, Samuel I. Yates. (Image courtesy of Betty Yates Jacobs.)

For over 100 years, a hardware store stood on Maryland Avenue just across from the railroad terminus. Prior to that, the building was a livery stable. Joshua Dorsey started the business delivering coal and ice in 1873 and expanded to carrying hardware. In 1924, Edward T. Clark purchased the establishment. The Clark family moved their business to Baltimore National Pike in the 1970s, and this building now houses an antique mall. (Then image courtesy of the Ellicott City Restoration Foundation.)

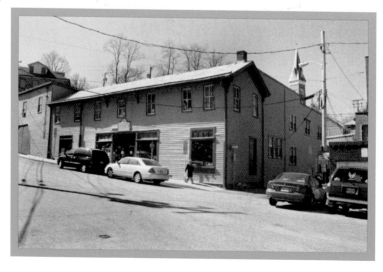

HARDWARE AND ANTIQUES

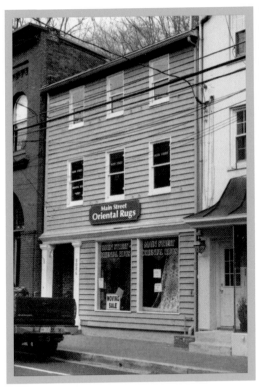

This property was one of those offered in the lottery of 1834. Currently a fine oriental carpet store, the building has in the past served as a private residence, a restaurant, and the Old Line Antique Shop. The opening of this shop in the early 1960s marked a turning point for the town, beginning its transition from a practical commercial hub to the tourist magnet it is today. (Then image courtesy of the Ellicott City Restoration Foundation.)

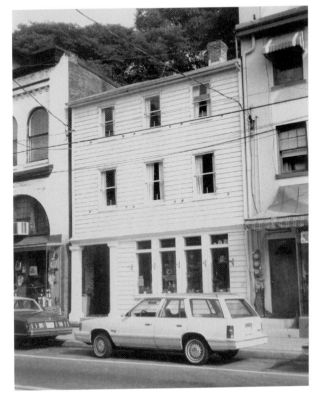

In the 1840s, this property was owned by William Fort, a cabinetmaker who had a furniture and undertaking business. Mr. Fort could supply furniture and accessory needs and also took raw lumber as payment. Other businesses at this location have included bars and grocery stores. Discoveries, a store that offers unique items crafted by artisans and often displays its colorful wares outdoors, is another of the independent businesses on Main Street.

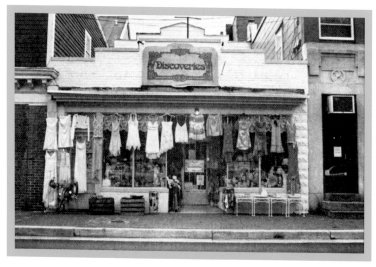

HARDWARE AND ANTIQUES

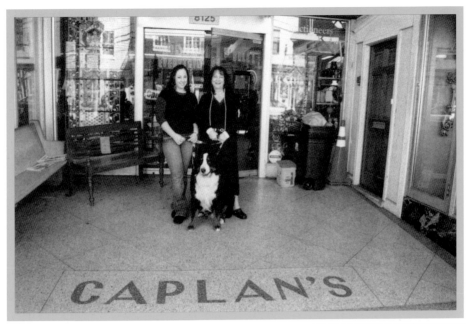

Noah and Rachael Caplan purchased the building that became Caplan's Department Store from Sol Davis in 1895. In 1923, their son Samuel left medical school to assist his widowed mother. They demolished two buildings and opened Ellicott City's Daylight Department Store in 1926 in a new building with large storefront windows and skylights. Sam and his wife, Gertrude, lived upstairs and ran the store until it closed in 1977. It is now an antique shop owned by Shelley and John Harris. Shown here are Chelsea and Shelley Harris (right) with JJ the dog. (Then image courtesy of Shelley Harris.)

In 1834, this Main Street property was deeded to George Ellicott Jr., who built a stone residence here. Later the building was used by a carpet weaver, Fissell's Grocery (pictured), and a Chinese laundry. For over a decade, the granite structure has housed Mumbles and Squeaks, a charming toy store featuring classics like paper dolls and elaborate doll houses. (Then image courtesy of Charlotte Holland.)

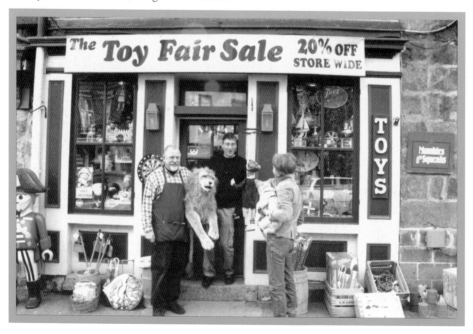

These three buildings on Main Street have over the years housed many businesses fondly remembered. The building on the left, now Sheppard Art Gallery, was once the telephone company and Pickwick Papers. The center building, now Cottage Antiques, has held a grocery store and pharmacy. The building on the right, Shoemaker Country, was in the past a drugstore, Gil's Lunch, and the locally legendary Dee's Kitchen. (Then image courtesy of the Ellicott City Restoration Foundation.)

Yates Market is the oldest continuously run business on Main Street. Currently Betty Yates Jacobs (shown here with Earl Klemm) continues the practice of her father, Bladen, always looking out for their customers, with amenities including home delivery of groceries. Their offerings include house-made sausage, and they do a brisk business in fresh turkeys and Chesapeake oysters during the holidays. It is notable that the telephone number on the side of the early vehicle is still part of the telephone number of the business today. (Then image courtesy of Betty Yates Jacobs.)

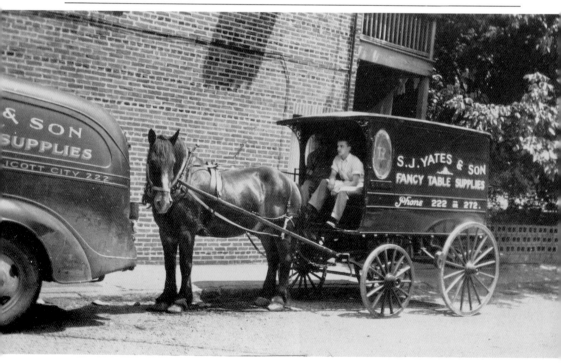

HARDWARE AND ANTIQUES

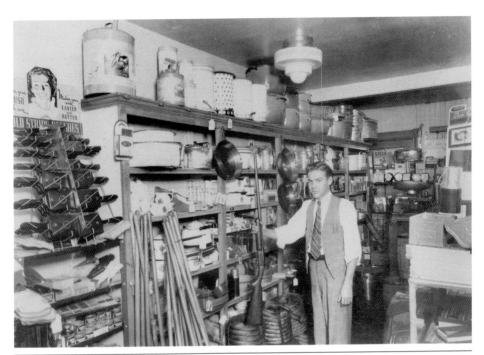

After Yates Market opened, Bladen Yates opened Yates Hardware next door in 1938. Ditty Yates managed the hardware store, caning chairs and making keys, while her husband Bladen managed the grocery store next door. Betty Yates Jacobs and her father, Bladen Yates, took over the hardware store after Ditty's death. The upper photograph shows Bladen in the hardware store, while the lower features Dwayne Hitchcock in the current antique and furniture shop. (Then image courtesy of Betty Yates Jacobs.)

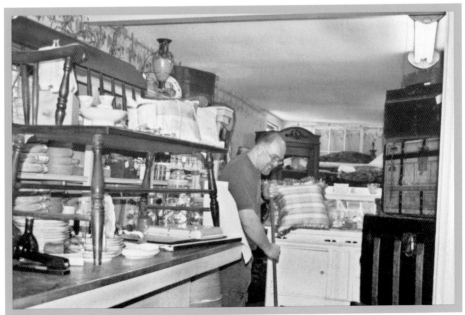

The five-story building housing the Forget-Me-Not Factory is the tallest structure on Main Street. Over the years, it has housed the town hall, a newspaper office, clothing manufacturers, and grocery and furniture stores. One favorite, although disputed, story is that John Wilkes Booth once performed in the town hall. Ed Rodey bought the building in the early 20th century and featured silent movies and other entertainment there. The current owners enjoy engaging visitors with sidewalk bubble blowing. (Then image courtesy of Barry and Nancy Gibson.)

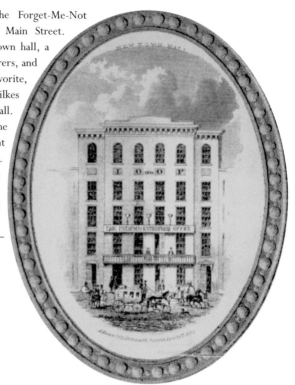

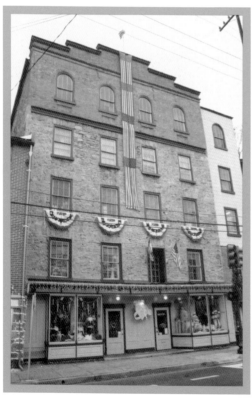

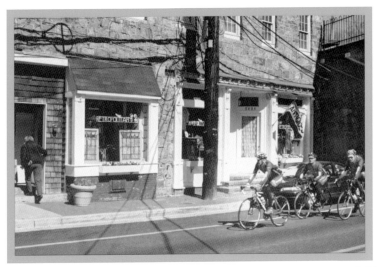

Retropolitan is an antique furniture and accessory store located in the lower level of the former Patapsco Hotel. For a time, the hotel welcomed passengers from the adjacent railroad, until passenger waiting rooms were added to the station itself. Over the years, this space has held a variety of retail shops, including a book store and a music store. The upper levels contain upscale apartments. (Then image courtesy of Charlotte Holland.)

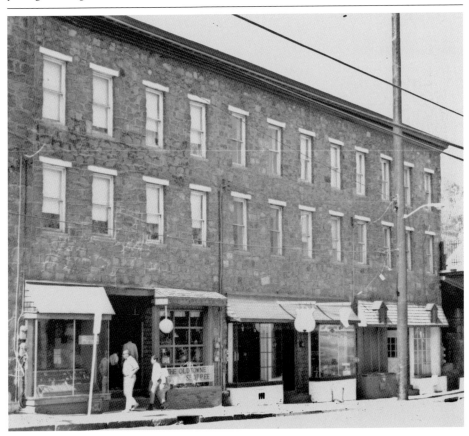

This unique building was built on property won by lottery in 1834 by Philip Earlougher, who sold it to the Talbotts. The Talbotts sold it to the Patapsco Bank, which moved to Main Street from its St. Paul Street location. Subsequently it housed several pharmacies and a liquor store. It is currently Gallerie 'Élan, a fine art gallery specializing in 19th- and 20th-century American art. (Then image courtesy of the Ellicott City Restoration Foundation.)

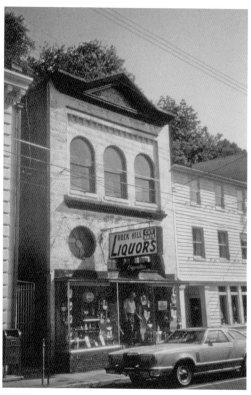

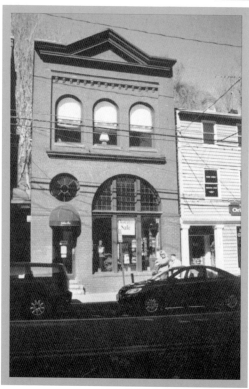

HARDWARE AND ANTIQUES

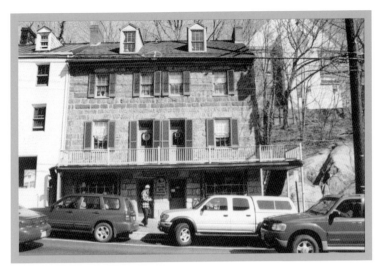

The Walker-Chandler house was built in the 1790s, the oldest duplex in the county. After serving as a private home, it was used as a boot maker's shop, a funeral home, a tavern, headquarters for the Red Cross, and the telephone company office. Ellicott's Country Store opened there in 1962, the second oldest business on Main Street. After a fire in 1975, restorers uncovered original fireplaces, wood flooring, and window paneling. A second fire in 1991 closed the shop for seven months. (Then image courtesy of Charlotte Holland.)

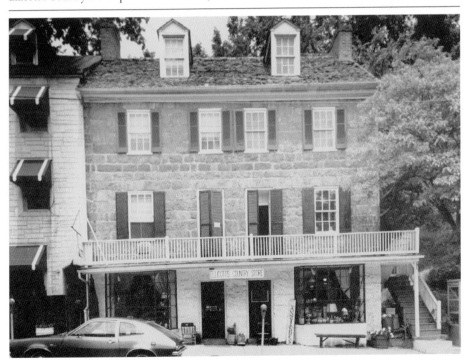

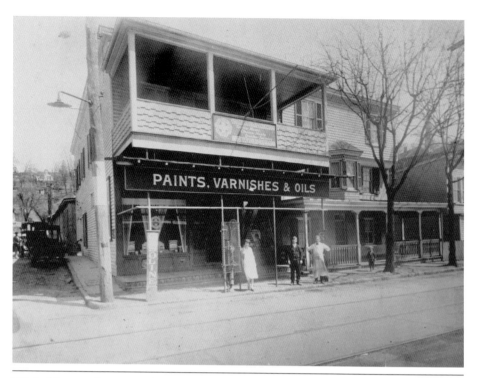

This building, on the corner of Main Street and Court Avenue, once held Feigley's store, which sold hardware supplies. They sold gasoline as well, and the gas storage tank was suspended under a bridge over the Hudson Branch of the river. Today it houses the office of Architectural Collaborative, which has taken optimum advantage of the building's situation over the river by installing a glass floor in their conference room, with a lighted view of the water beneath. (Then image courtesy of Doris Thompson; now image courtesy of Scott Habicht.)

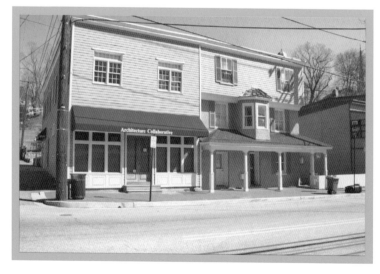

HARDWARE AND ANTIQUES

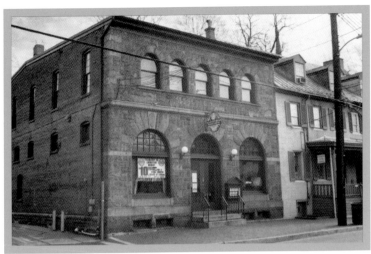

Edward Alexander Talbott opened his first lumberyard, which was destroyed during the flood of 1868, on the east bank of the Patapsco River. He then relocated to a spot west of the B&O Railroad Station on Maryland Avenue and later to this location farther west on Main Street. The lumberyard closed in the mid-1990s, and the building was reopened in 1996 as the Ellicott Mills Brewing Company, a well-designed restaurant and microbrewery. (Then image courtesy of Charlotte Holland.)

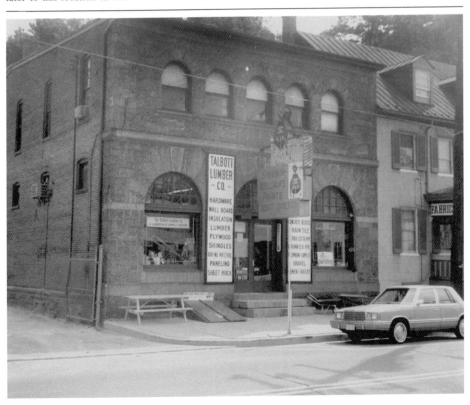

The Ellicott Theater was built in 1940, after fire destroyed the frame buildings previously on the site. This art deco–style building is made of glazed terra cotta and features glass brick accents. Over the years, it has housed a movie theater, a nightclub called Superstar, and an acting school for children. Today it is part of Precious Gifts, a store featuring accessories and collectables. (Now image courtesy of Scott Habicht.)

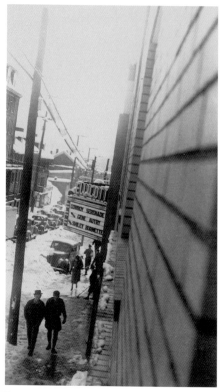

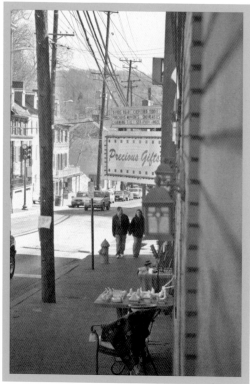

GRANITE AND
GOVERNMENT

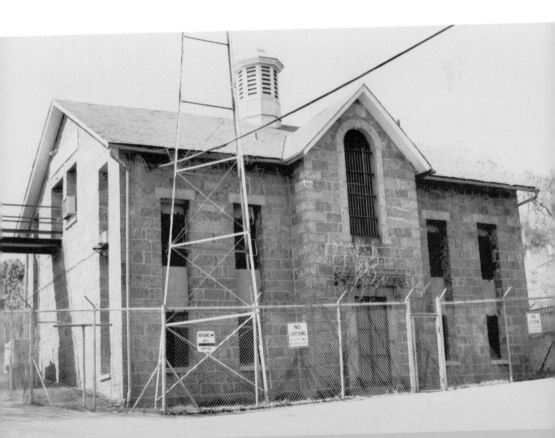

Built in 1878, the jail at Park Avenue and Emory Street was known as "Willow Grove." In the early 20th century, Police Chief Julius Wosch had such authority that he would merely send for culprits rather than picking them up himself, and they would come. This, like many of Ellicott City's public buildings, incorporates the local granite. (Image courtesy of Charlotte Holland.)

This small granite building behind the Thomas Isaac Log Cabin at Main Street and Ellicott Mills Drive was Howard County's first courthouse, operating from 1840 to 1843, while the large courthouse on Capitoline Hill was being built. In 1998, it opened as the Heritage Orientation Center and contains an exhibit on the fires, floods, and the Ellicott family that shaped the town. This is an excellent place to begin a visit to the historic district of Ellicott City. (Then image courtesy of Charlotte Holland.)

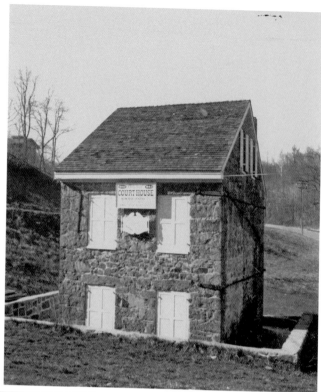

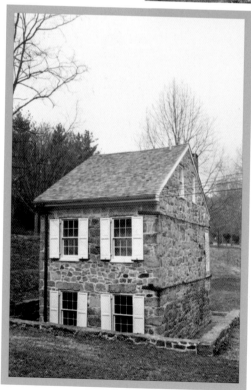

GRANITE AND GOVERNMENT

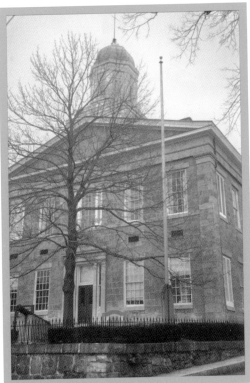

The neoclassical courthouse, completed in 1843, is on top of Capitoline Hill. This hill is also referred to as Mount Misery, possibly due to the miserable task of moving granite blocks up the hill to the building site. The architect was Samuel Harris. The builder was Charles Timanus, who also built the Patapsco Female Institute. Construction cost $28,000. Major additions were undertaken in 1938–1939 and again in 1986, but it remains a cramped and inadequate space.

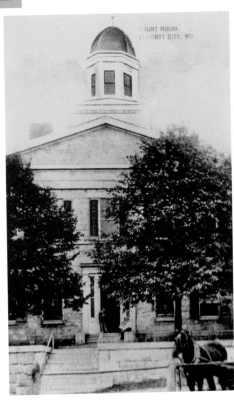

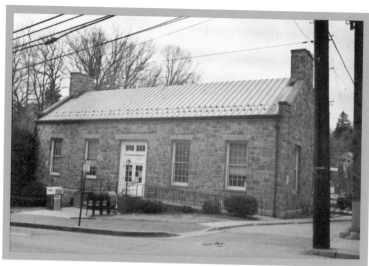

The office of postmaster was established at Ellicott's Lower Mills on October 2, 1797. Samuel Godfrey was the first postmaster. In the 1930s, six frame buildings—including Samuel Hillsinger's Undertaking Parlor, established during the Civil War—were demolished to clear the site for the current post office. Two murals portraying the history of Ellicott Mills, commissioned by the Works Progress Administration and painted by artist Petro Paul DeAnna, adorn the interior today. (Then image courtesy of Betty Yates Jacobs.)

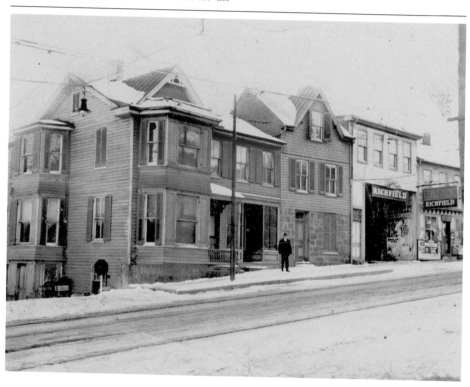

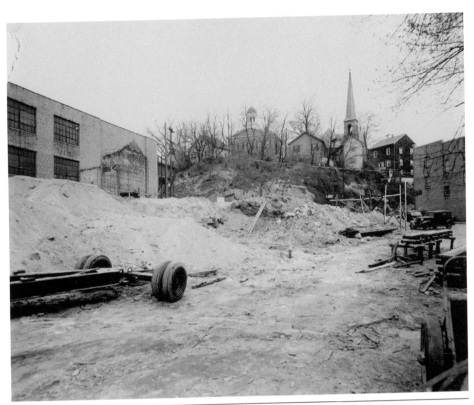

The new post office was dedicated on December 7, 1940. On that day, the Ladies Auxiliary of the Ellicott City Volunteer Fireman's Association served a turkey lunch to 150 guests at the firehouse. Local dignitaries were present, and the Dickey Band provided entertainment. Michael J. Sullivan was the first postmaster at the new location. Currently the building also houses the Visitors Center for the Howard County Tourism Council and the office of Historic Ellicott City, Inc. (Then image courtesy of the Howard County Tourism Council.)

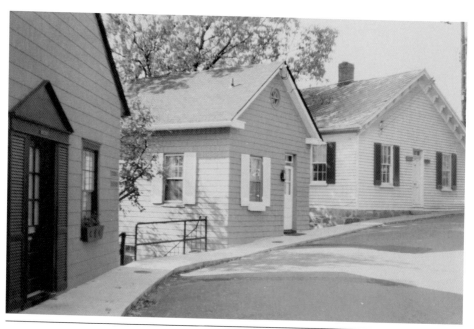

Pictured on the right is the oldest of the offices on Lawyer's Row. It was built *c.* 1869 for Henry Edgar Wooten, Esq., and sits across from the original entrance to the Howard County Courthouse. Designed to accommodate two lawyers, the office still contains its original law library. It is the oldest law office in Howard County and one of the oldest buildings in continuous use as a law office in Maryland. (Then image courtesy of Charlotte Holland.)

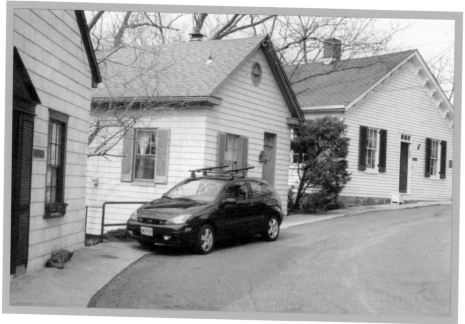

GRANITE AND GOVERNMENT

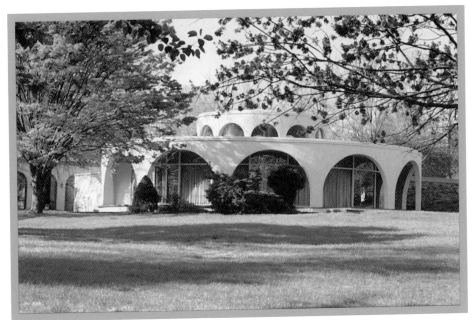

The Patapsco Manor Sanitarium was founded in 1907. In 1939, Isaac Taylor purchased the 12-bed facility from the estate of Dr. Rushmore White for the purpose of operating a psychiatric hospital known as the Pinel Clinic. The first major expansion occurred in 1948 and increased bed capacity to 48 beds. The New Center opened in 1968 with 151 beds. The operation of the facility continues through the partnership of Dr. Bruce Taylor and the Sheppard Pratt Health System.

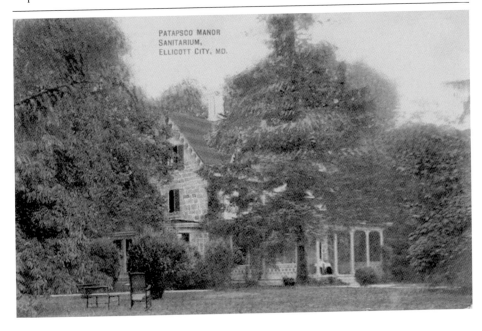

PATAPSCO MANOR
SANITARIUM,
ELLICOTT CITY, MD.

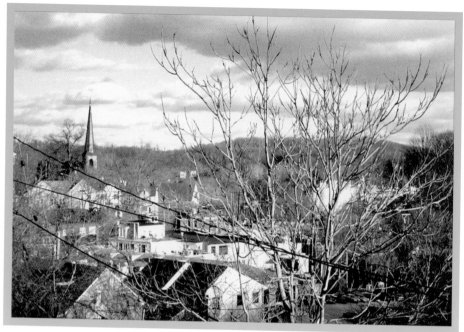

Standing above the south side of Main Street, it is interesting to view some of the town's most important landmarks. The courthouse and the Howard County Historical Society, housed in the former Presbyterian church, stand out on top of Mount Misery, the church's spire arguably the high point of the town. Also visible and relatively unchanged are the tiny cottages that make up Lawyer's Row. All serve as reassuring constants in our times of change. (Now image courtesy of Earl Klemm.)

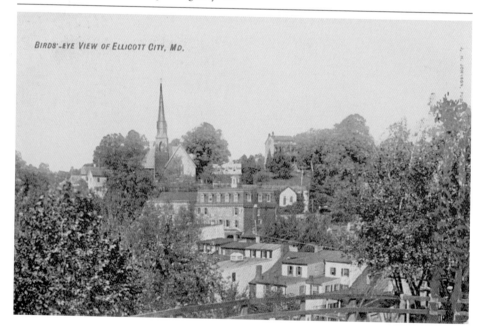

BIRDS'-EYE VIEW OF ELLICOTT CITY, MD.

READING, WRITING, AND RELIGION

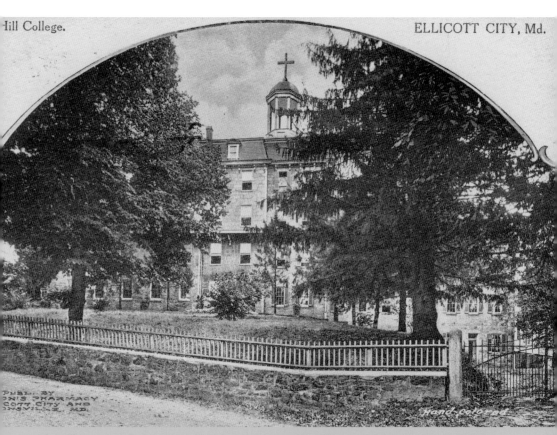

Hill College. ELLICOTT CITY, Md.

PUBL. BY
IN'S PHARMACY
COTT.CITY AND
INGVILLE, MD.

Hand-colored

The Ellicotts had high regard for education, donating land for the establishment of several schools. Rock Hill College educated young men from 1865 until destroyed by fire in 1923. In 1925, the Ellicott City High School opened on this site, using stones from Rock Hill. For many years, this was the location of the Fireman's Carnival. It is now condominiums.

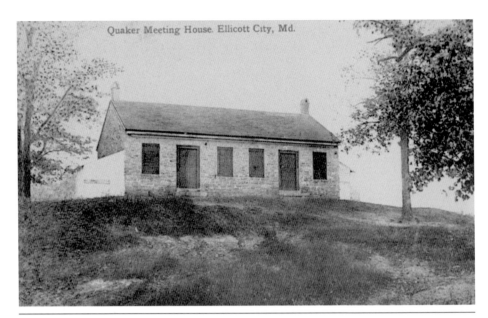

Quaker Meeting House. Ellicott City, Md.

In 1800, the Ellicotts built a Quaker meetinghouse on their cemetery grounds. It was known as the new Elkridge meetinghouse, or Quaker Hill. The first service in the new meetinghouse was the wedding of Cassandra Ellicott, widow of John Ellicott, and Joseph Thornburg. It closed as a meetinghouse in 1816. It was used as a hospital during the Civil War and later as a school. It is now a private residence.

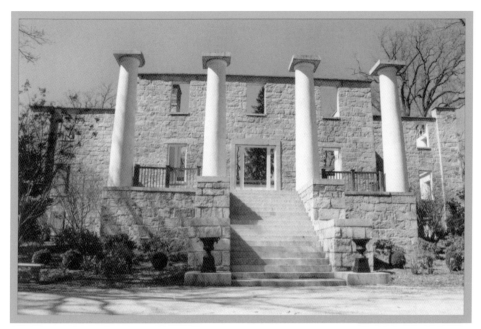

The Patapsco Female Institute opened as a school for young women in 1837. It was a Greek Revival–style building with four huge Doric columns. The school closed in 1890 and then was used as a hospital, nursing home, and theater before falling into decay. Listed on the National Register of Historic Places, it was reopened as the Patapsco Female Institute Historic Park in 1995. Now a stabilized, open-air ruins, it is used for archeological digs, weddings, ghost tours, and Shakespeare performances.

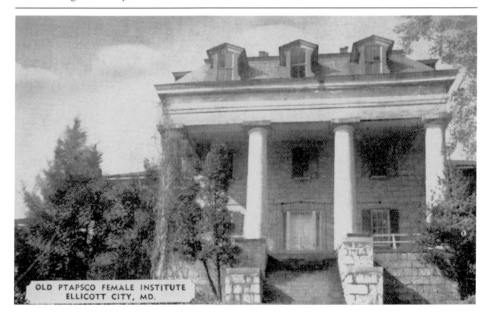

OLD PTAPSCO FEMALE INSTITUTE
ELLICOTT CITY, MD.

In 1889, a public four-room grammar school opened on School Street, now Park Avenue. Students traveled a footpath known as Strawberry Lane from Main Street to the school. In 1902, Howard County's first public high school was opened when several rooms were added to the grammar school. After the building was demolished, P. G. Stromberg, publisher of *The Times*, purchased three lots there from the board of education and built three homes, which still stand.

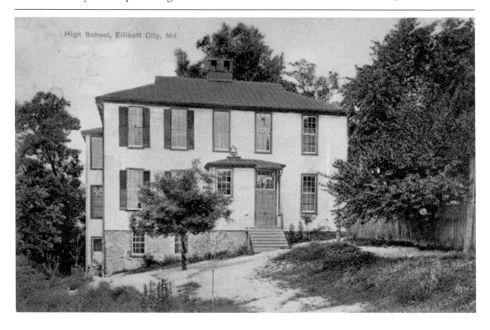

High School, Ellicott City, Md.

READING, WRITING, AND RELIGION

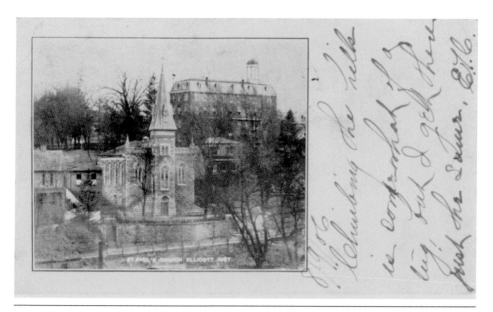

St. Paul's Roman Catholic Church opened on September 13, 1838. The building is gray granite, quarried locally. During the Civil War, the basement of the church was used as a hospital for both Northern and Southern soldiers. Babe Ruth married here. Over the years, the church has been renovated and restored, including a ramp for handicap access. In 1974, the parish outgrew its current location and split, creating a new parish, the Church of the Resurrection, a few miles away.

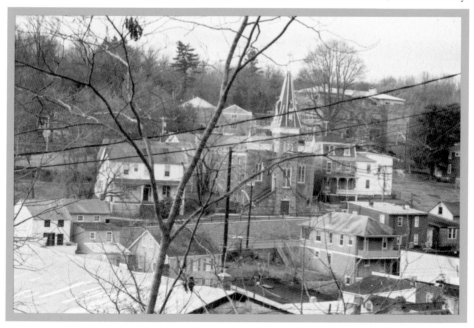

Emory Methodist Episcopal Church was completed in 1838. Construction cost was $6,181.34. The stonemason was Jake Timanus, the carpenter was W. S. Harrison, and the plasterer was Jesse McKenzie. In 1888, it was remodeled at a cost of $3,500, and the stained-glass window resembling a sunflower was added. In 1892, electric lights were installed, and around 1900, plumbing was added. The external appearance has changed little over the years.

COLONEL POWELLS ROCK, ELLICOTT CITY, MD.

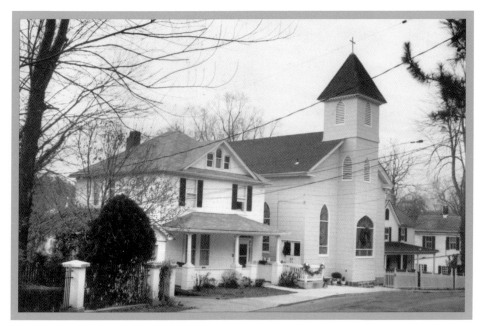

The First Lutheran Church on Church Road was founded in 1874 by German immigrants. Completed in 1875, the church cost $3,500 to construct. Services were held in German, and German-speaking children attended school in the basement. In 1956, the congregation moved to a new site at Frederick and Chatham Roads, and the church became the First Gospel Tabernacle. It is now a private home featuring dramatic ceiling heights and the original stained-glass windows.

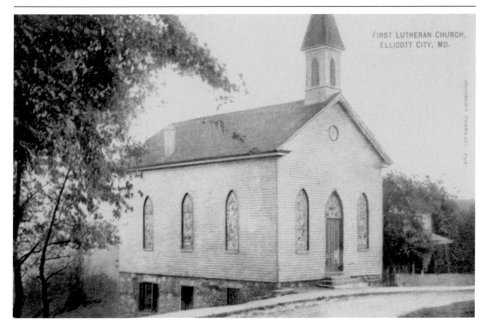

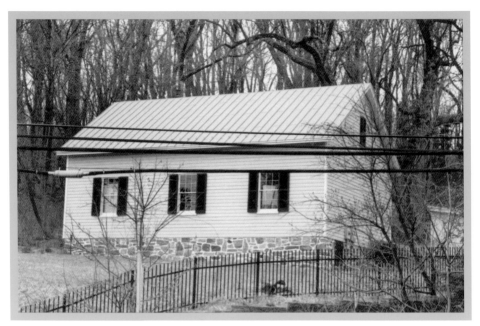

The Ellicott City Colored School, Restored, was built in 1880 and used until 1953. It is the first school built with public funds for black children in Howard County. A coal-fired potbellied stove heated the school. There was no electricity, water came from an outdoor pump, and a path led to the twin outhouses. The building was repurchased by the county in 1995 and restored. It is now a museum with programs sponsored by the Afro-American Historical and Genealogical Society.

READING, WRITING, AND RELIGION

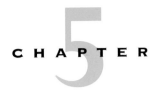

CHAPTER 5

CABINS AND CASTLES

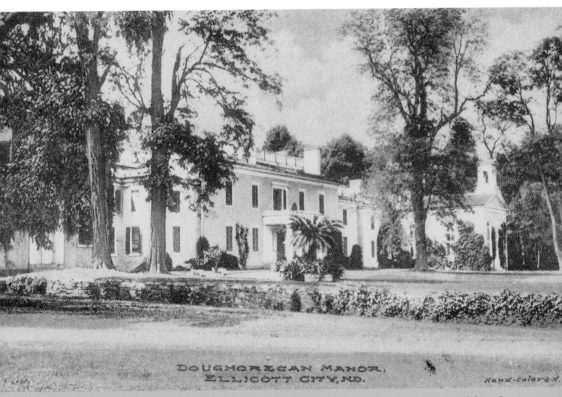

DOUGHOREGAN MANOR,
ELLICOTT CITY, MD.

Hand-colored

Built around 1727, Doughoregan Manor was the home of Charles Carroll of Carrollton, a signer of the Declaration of Independence. The property has been in the same family for its entire existence, but its future is uncertain because of the possibility of subdivision. It is a reminder to treasure our cabins and our castles, as the past informs the future.

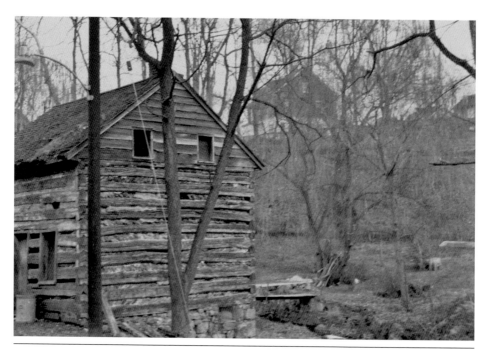

Originally located on Merryman Street, the *c.* 1780 building known as the Thomas Isaac Log Cabin was donated to Historic Ellicott City, Inc., by the Stanton family for preservation. In 1980, the cabin was dismantled and stored, and it was later reassembled on its new site at Main Street and Ellicott Mills Drive in 1987. Today it is the headquarters of the county's Ellicott City Historic Sites Consortium. It is the oldest building in the historic district of Ellicott City. (Then image courtesy of Charlotte Holland.)

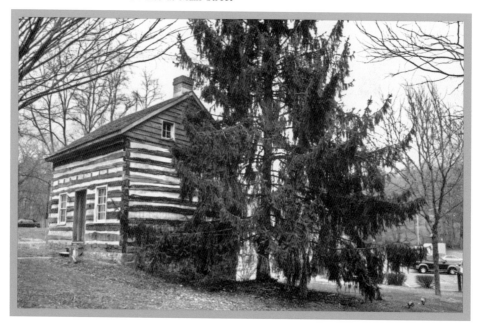

CABINS AND CASTLES

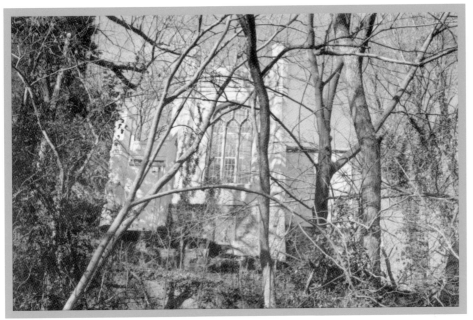

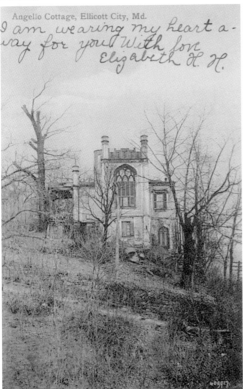

Angello Cottage, Ellicott City, Md.

*I am wearing my heart a-
way for you. With love
Elizabeth H. H.*

Castle Angelo, a miniature copy of a French castle of the same name, was built of native granite and imported lumber in 1831 by architect Samuel Vaughn. It features Gothic windows and octagonal chimneys. It served as a rectory for the first Catholic priests in the area, and the first Catholic mass in Ellicott's Mills was said there. It sits on an acre and a half of almost vertical land and has been extensively restored.

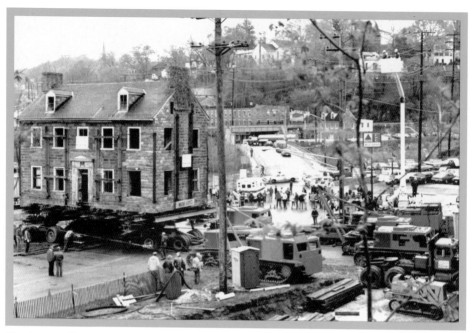

The George Ellicott House was built in 1789 for the son of Andrew Ellicott, one of the founding fathers of the town. It is an H-shaped double house with a mother-in-law wing in the back. For nearly two centuries, it withstood floods, road rerouting, and the encroachment of commercial enterprise as it stood next to the Jonathan Ellicott House, across from the original Ellicott's Mill. (Then image courtesy of Herb Johl; now image courtesy of Charles Wagandt.)

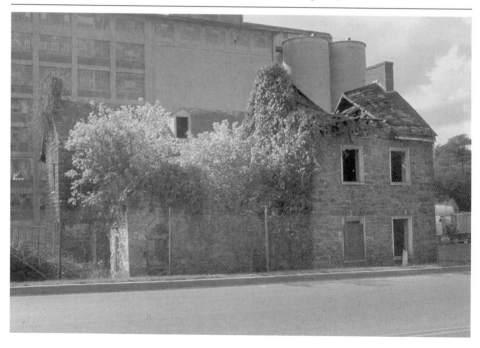

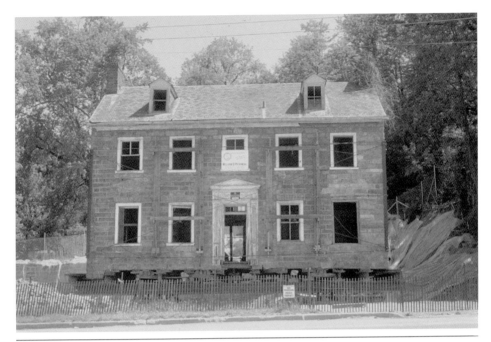

Floodwaters from Tropical Storm Agnes in 1972 and Hurricane Eloise in 1975 seriously damaged the George Ellicott House. A partnership of Historic Ellicott City, Inc., and the Oella Company proposed moving the house across the street to a safer location. On April 25, 1987, the house was moved to its current location and then rebuilt. The cost of the move and restoration was over $1 million. It currently houses a business. (Then image courtesy of Herb Johl.)

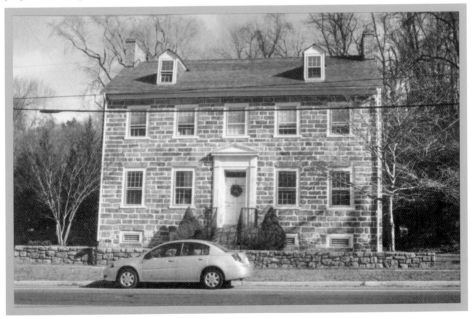

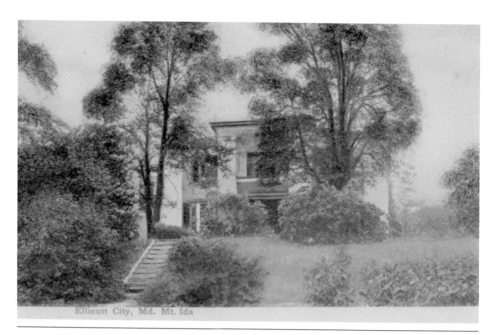
Ellicott City, Md. Mt. Ida

Mount Ida was the last house built in the historic district for an Ellicott. Built in 1828 for William Ellicott, it later became the home of Judge John Tyson. It is believed that the house is named after his daughter Ida, who lived in the home her whole life. The Miller Land Company purchased the house in the 1970s and stabilized it. It has been restored and is now the Visitor Center for the Patapsco Female Institute Historic Park.

This granite house was erected in 1782 by Jonathan Ellicott, the oldest son of founder Andrew and brother of George. Jonathan was one of the planners of the Baltimore-Frederick Turnpike. He lived in the house until his death in 1826. The house stood for nearly two centuries, in front of the Ellicott Mill and next to his brother George's house, until destroyed by the flooding of Tropical Storm Agnes in June 1972. (Then image courtesy of Charles Wagandt; now image courtesy of Scott Habicht.)

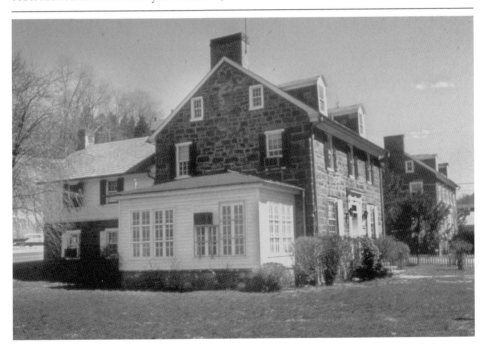

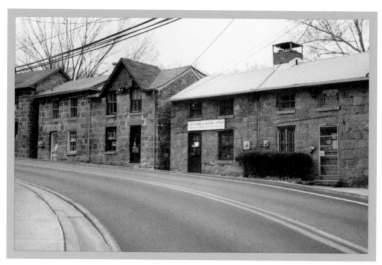

Tongue Row on Columbia Pike is one of the most picturesque spots in Ellicott City and one of the most photographed. Built in the early 1800s for mill workers and leased by Ann Tongue, the stone structures seem to be one unit, although they are really six. In 2000, a film crew used the buildings as a backdrop for a production of *Les Miserables*, believing they approximated the look of 19th-century France. (Then image courtesy of Charlotte Holland.)

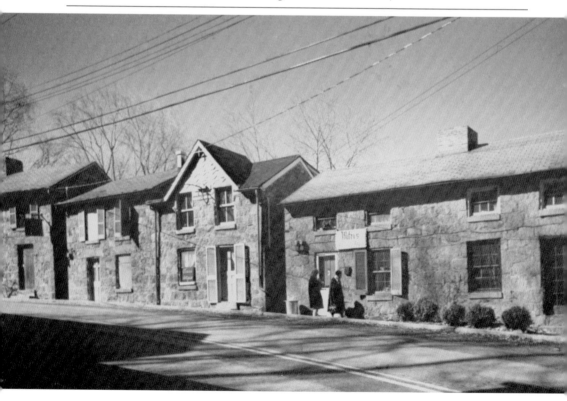

CABINS AND CASTLES

Built in the early 1800s, this charming neoclassical, two-and-a-half-story, white brick house on Columbia Pike has been a teahouse, a café, and a private residence. It now houses an upscale salon, envy, whose owners respect the historic elements of the structure and creatively preserved them when they adapted the building for commercial use. They avoided drilling into the plaster walls and outfitted the premises with traditional colors and antique furniture while retaining function. (Then image courtesy of Charlotte Holland.)

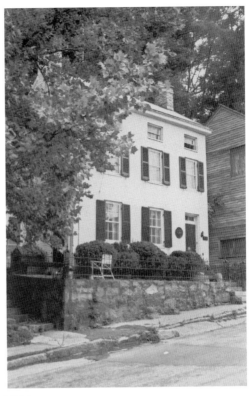

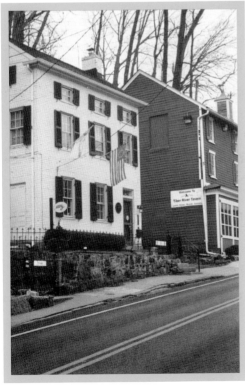

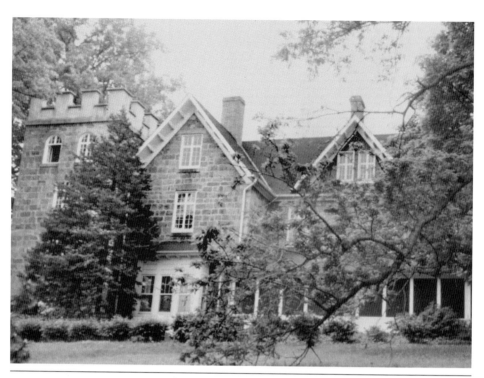

Lilburn was built in 1851 by Richard Henry Hazlehurst. A Gothic Revival stone building with a bell tower and turret, it is one of the most unique residences in Maryland. Hazlehurst sided with the Confederacy during the Civil War, and Lilburn was visited by Robert E. Lee. It is one of Ellicott City's most notable haunted houses—many think the ghost of Mr. Hazlehurst remains to watch over his property. (Then image courtesy of Charlotte Holland; now image courtesy of Scott Habicht.)

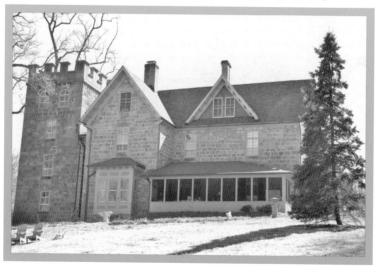

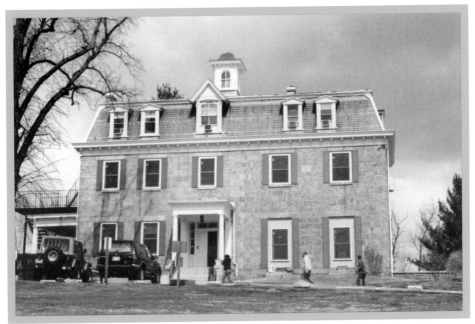

Built of local granite, Linwood stands at the end of Church Road. The oldest part of the house dates from the 1780s, while the newer addition is over 100 years old. It was built by slaves and during the Civil War was owned by Southern sympathizers, the Peter family. It remained a private home until 1955, when it opened as the Linwood Children's Center, now nationally recognized for its groundbreaking work with autistic children. (Then image courtesy of Charlotte Holland.)

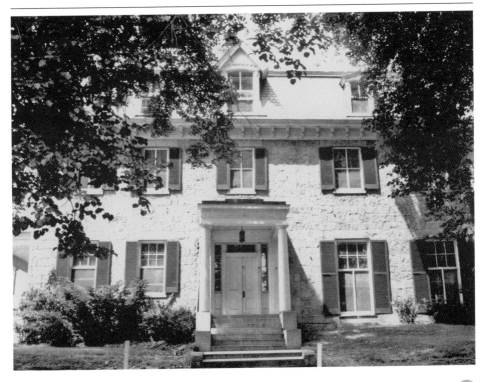

CABINS AND CASTLES

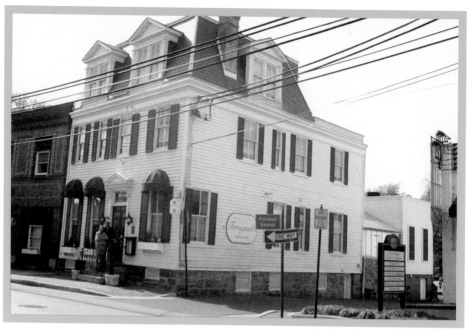

This large, white frame, French-influenced, Mansard-style house was built in the 1840s by Dr. Mordecai Gist Sykes as his home and dental office. Dr. Sykes was mayor of Ellicott City from 1889 to 1897. Later used as government offices, it is now the home of Tersiguel's French Country Restaurant. The Tersiguel family formerly had a restaurant farther down Main Street called Chez Fernand, which was destroyed in the fire of 1984. (Then image courtesy of the Ellicott City Restoration Foundation.)

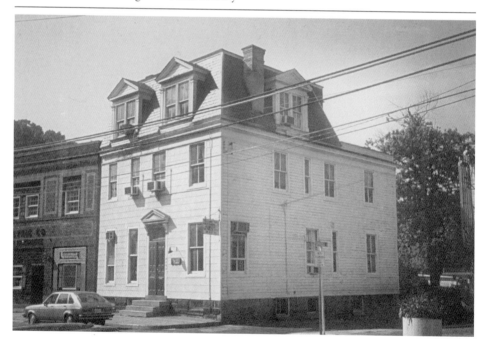

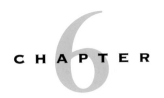

CHAPTER 6

MILLS, MENUS, AND MUSEUMS

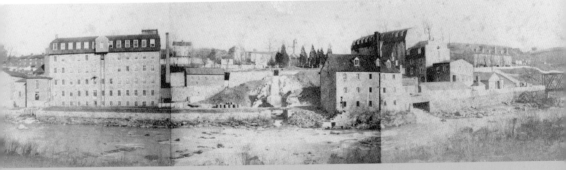

At one time, the Ellicott City area had seven mills, including the Union Manufacturing Company, shown during the Civil War. The Ellicotts built not only mills but also lodging for their workers. In time came the inns and other amenities needed for daily life. In its industrial prime, Ellicott City was one of the premier manufacturing sites in America.

Burgess Mill is one of the seven mills that were located in Ellicott City. It was on Main Street, just west of Ellicott Mills Drive. It operated as a mill as early as 1823. It was a gristmill for three months of the year and a wagon works for the rest of the time. The mill was powered by water from the Hudson Branch. (Then image courtesy of the Howard County Historical Society.)

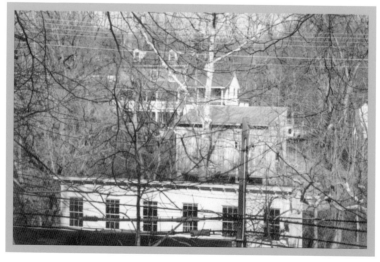

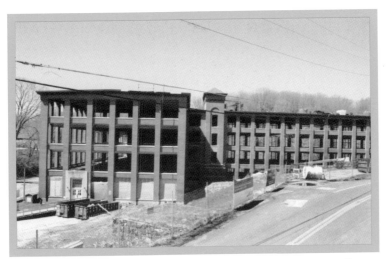

The Oella Mill, once the largest cotton mill in America, was built in the early 19th century and named in honor of the first woman in the United States who worked at spinning cotton. The current building replaced one that was destroyed in a fire in 1918. After the mill closed in 1972, Charles Wagandt, great-grandson of mill owner William Dickey, bought the mill and restored it. It served as an antique center and is now being converted into luxury condominiums. (Then image courtesy of Charles Wagandt.)

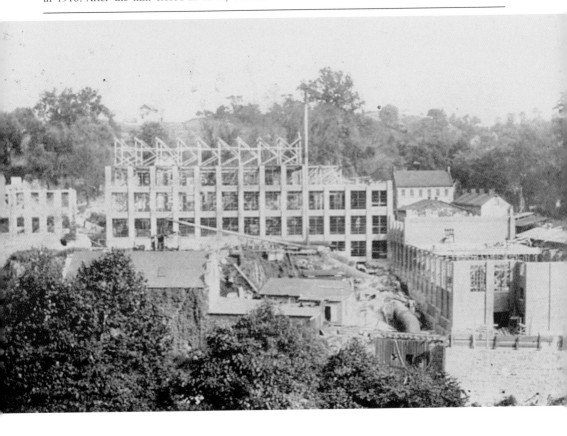

The Howard County Historical Society Museum is housed in the former First Presbyterian Church, built in 1844 and rebuilt in 1894. In 1960, the church outgrew the facilities. Alda Hopkins Clark bought the church and donated it to the society (which she founded) in memory of her husband, Judge James Clark. The church is built of rock quarried locally, and it features a tall, spire-like bell tower. The museum houses memorabilia related to the history of Howard County.

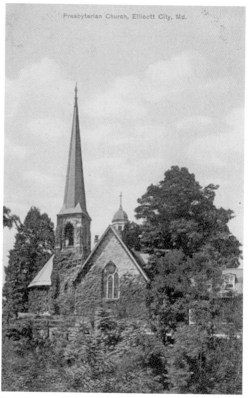

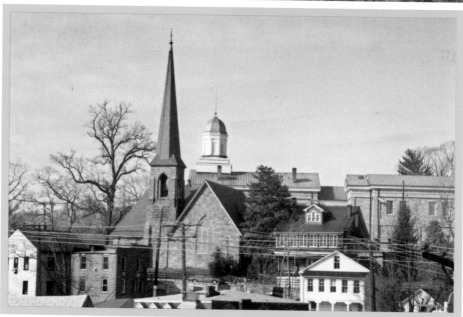

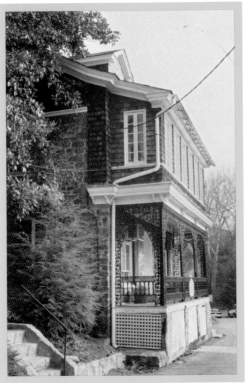

The Howard County Historical Society Library building was built in the late 18th century as the Ellicott Mills Quaker School. It was used as a hospital during the War of 1812. In turn, it was a private residence, a county office, a newspaper office, then the public library. The historical society opened it as a library in January 1989. Only the stone part of the building is thought to be original—the rest, including ornamental ironwork, are later additions. (Then image courtesy of Charlotte Holland.)

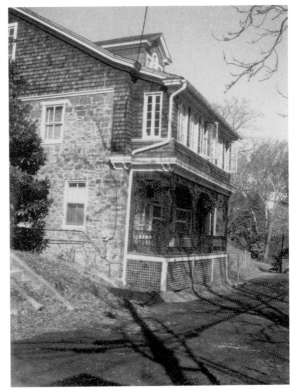

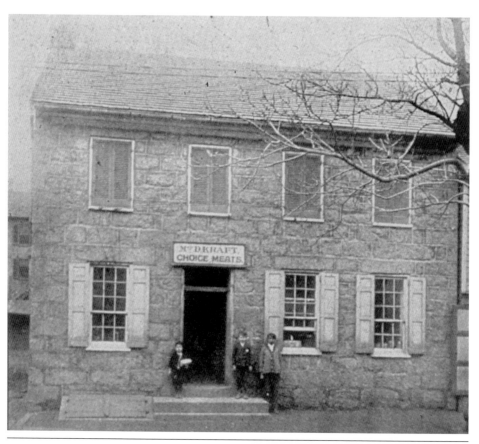

This small granite house, built in the 1830s, is one of the least-changed facades on Main Street. Dorothy Kraft bought the building in 1881 and opened Kraft's Meat Market. Today it contains the Source Unlimited, which is a design shop, and Tea on the Tiber, which is a British-style tea room with views of Main Street and the Tiber River. (Then image courtesy of the Ellicott City Restoration Foundation.)

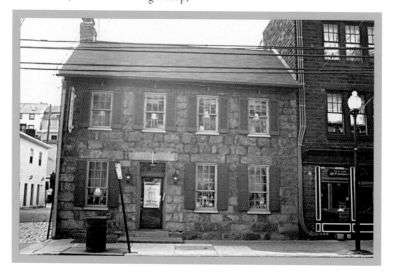

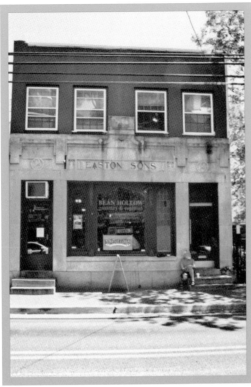

This sturdy stone-and-brick structure was built in the 1930s. It replaced an earlier frame building. For over 70 years, this was the site of Easton's Funeral Home, which followed Fort's. More recently, there have been several coffee shops in this location, including the current Bean Hollow, which is famous for roasting its own beans. The name Easton's can still be seen carved in the stone above the door. (Then image courtesy of the Ellicott City Restoration Foundation.)

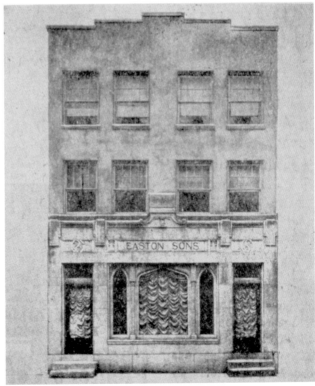

This is one of six buildings destroyed in the Main Street fire of 1984. At that time, it was a restaurant called Chez Fernand, owned and run by the Tersiguel family. They relocated to Baltimore and ultimately returned to another location on Main Street. Before the restaurant, the building housed a private residence and several stores. After the fire, this brick building was erected, which currently houses I Love Theatre. (Then image courtesy of the Ellicott City Restoration Foundation.)

Leidig's Bakery was one of the businesses destroyed in the six-alarm fire on November 14, 1984. This was one of the worst fires on Main Street, personally experienced by Victoria Goeller, who stood on the roof of Cacao Lane Restaurant across the street, hosing down the building to protect it from flying sparks. Before Leidig's, the building was a residence, a grocery store, and a five-and-ten. It was rebuilt after the fire and currently houses Fisher's Bakery. (Then image courtesy of David Ennis.)

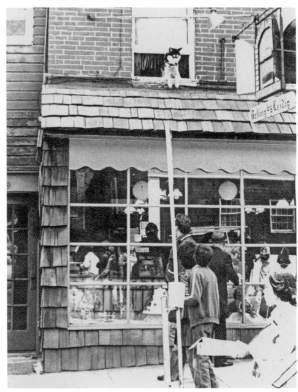

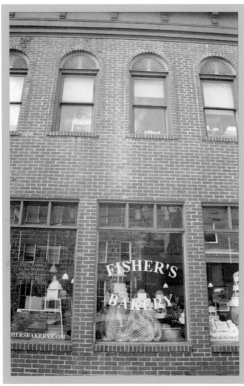

Disney's Tavern is a large duplex, one of the town's oldest landmarks, built in the 1790s. In 1840, Deborah Disney operated a popular tavern and inn here. Its location on Main Street with a rear exit off the second floor made the building a popular shortcut to the courthouse. It later became a private residence and now houses several businesses. (Then image courtesy of Charlotte Holland.)

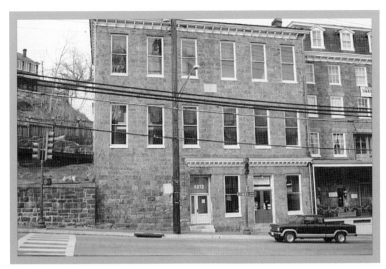

This Italianate stone-and-brick building was constructed as an addition to the Howard House in the late 1800s. From 1956 to 1981, it housed Paul's Market, owned by William P. Corun—a must-stop on everyone's list during that era. It has also housed a pool hall and a barbershop. It is now Annabell's, an interesting wine and gourmet food shop. (Then image courtesy of Charlotte Holland.)

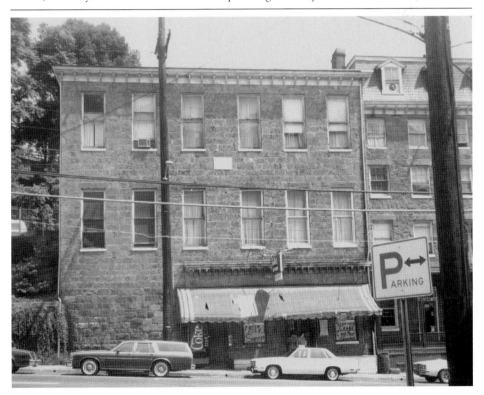

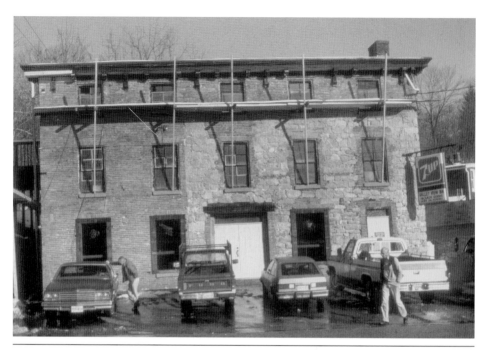

The Trolley Stop first opened as a tavern and country inn in 1833. In 1890, it became a general store. For much of the 20th century, after acquiring a liquor license, the business was nicknamed the "Bloody Bucket." Joe and Mary Ellen Morea purchased the building in 1981, expanded the kitchen, and greatly improved the image. The trolley did stop here from 1898 to 1955. The Fields family now runs the restaurant, which is family oriented. (Then image courtesy of Charles Wagandt.)

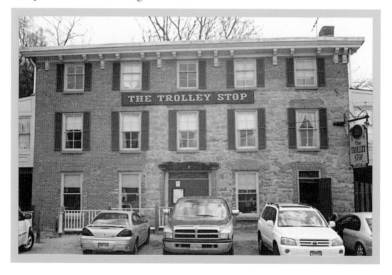

MILLS, MENUS, AND MUSEUMS

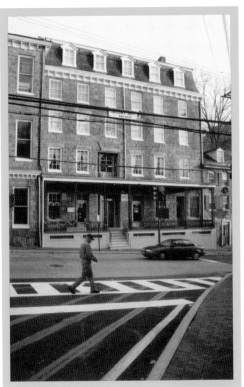

The Howard House was a hotel built by Christian Eckert in 1850 to accommodate visitors from Baltimore and Washington, D.C., traveling to escape the summer heat in the city. It offered pleasant rooms and fine dining, with specialties being house-made sodas and ice cream. Mr. Eckert later became mayor of the town after it was incorporated. Over time, most of the elaborate grillwork was removed, and the building now houses apartments and retail businesses. (Then image courtesy of Charlotte Holland.)

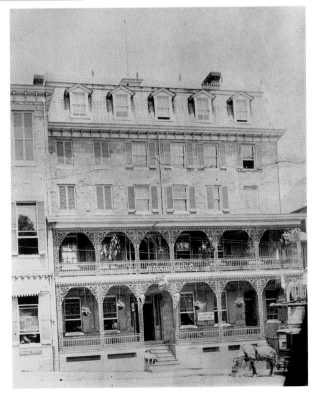

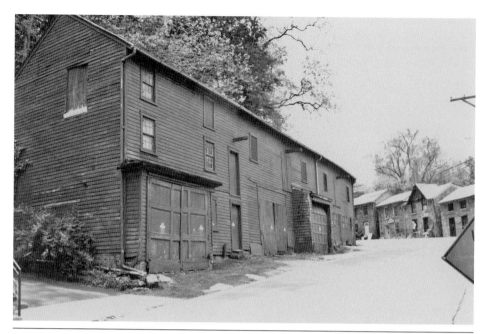

This building was once a stable and housed a blacksmith's shop as well. As with all structures in the historic district of Ellicott City, the restorers of this building had to adhere to a strict set of guidelines to retain historic integrity. The owners did so well they were recognized for their achievement with a preservation award. The building now houses the Tiber River Tavern. (Then and now images courtesy of David Ennis.)

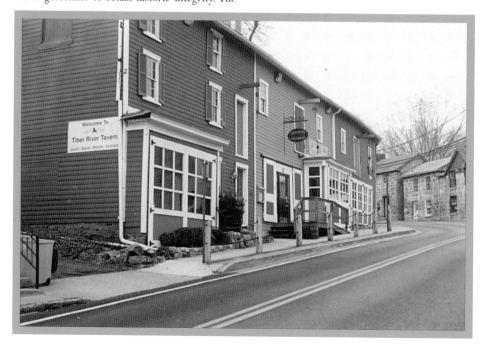

MILLS, MENUS, AND MUSEUMS

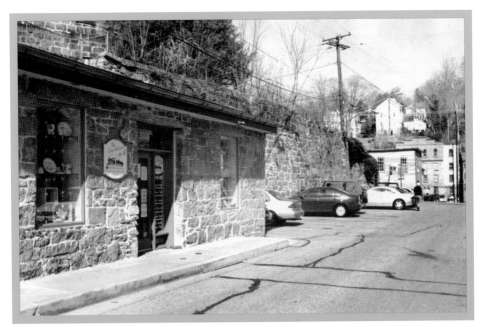

This small, one-story, native granite building was once a stable and later served as a storage shed for the railroad. The adjoining frame buildings were demolished in 1980 to enlarge the adjacent parking lot. The remaining building later housed a toy shop, and then the location became a pizzeria, followed by a crafts store. (Then image courtesy of Herb Johl.)

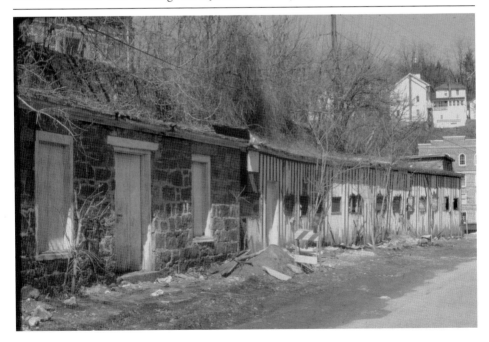

The Phoenix Emporium is on the right. Bernard Fort occupied this space from 1858 to 1887. Fort made coffins for victims of the great flood of 1868, and their bodies were laid out here. John O'Brien opened a saloon here in 1887, followed by others until the building was damaged by Hurricane Eloise in 1975. George Goeller purchased and renovated the building and opened the Phoenix Emporium in 1979.

CHAPTER 7

FIRES, FLOODS, AND FORCES OF NATURE

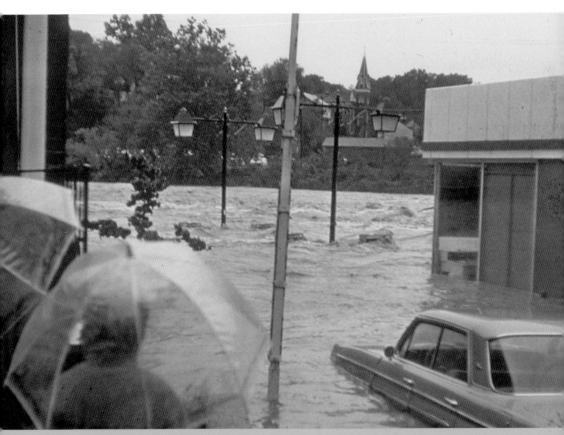

A river runs through the historic district of Ellicott City. Its high granite hills create natural boundaries, affecting both the dispersion of water in times of flooding and the ability to fight fires when these tragedies occur. Ellicott City is very much a servant of nature and has learned from these past occurrences, such as Hurricane Eloise in 1975, to plan for the future. (Image courtesy of Bob Miller.)

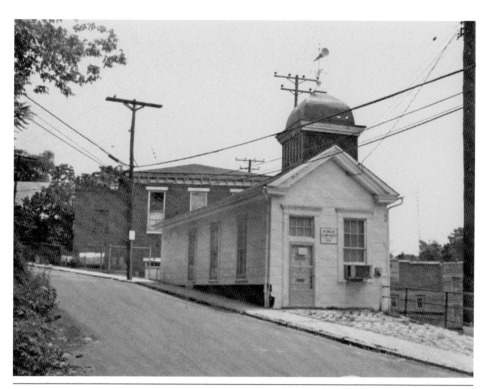

Ellicott City got its first official volunteer firefighting company in 1888. The first firehouse was built on land donated by Christian Eckert, owner of the Howard House, who was elected mayor in 1890. Volunteers kept the cost down by doing a lot of labor at no charge, completing the building in 1889. It was in use from 1889 to 1923 and then housed county offices and later the public library. It was turned into a museum in 1991. (Then image courtesy of Charlotte Holland.)

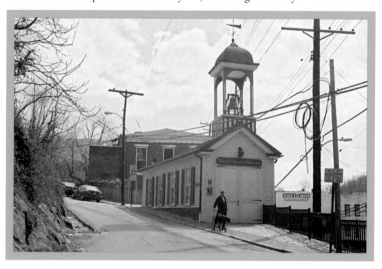

FIRES, FLOODS, AND FORCES OF NATURE

This building was completed in 1939 at a cost of $43,000. In the early 1940s, it was the scene of a Decoration Day celebration. It served as the sole fire station in the Historic District of Ellicott City until 1998, when the department moved to a new building on Montgomery Road. This building now houses an antique shop. (Then image courtesy of Shirley Bossom.)

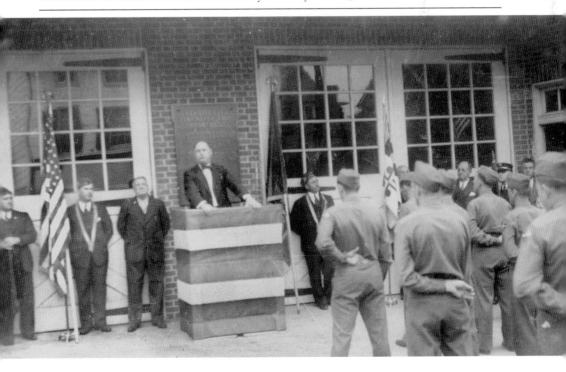

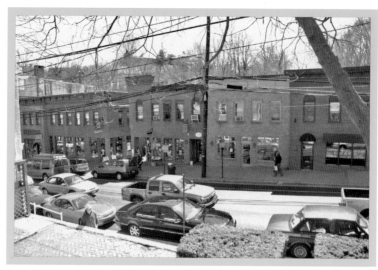

On November 14, 1984, a fire broke out in the back of Leidig's Bakery in the middle of Main Street. It quickly spread to five other buildings, including Chez Fernand Restaurant, the Antique Clock and Watch Shop, Marino's Frame and Art Shop, Chateau Wine Supply, and the Iron Rail. At times, flames were over 100 feet high. All six buildings were destroyed. Today this block of rebuilt buildings houses Fisher's Bakery, Andre's Barber Shop, and a variety of retail stores. (Then image courtesy of Sandy Lerner; now image courtesy of Scott Habicht.)

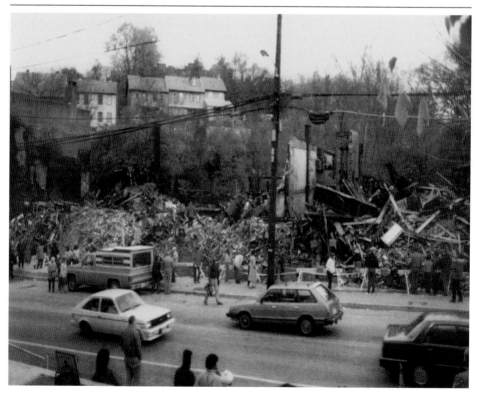

FIRES, FLOODS, AND FORCES OF NATURE

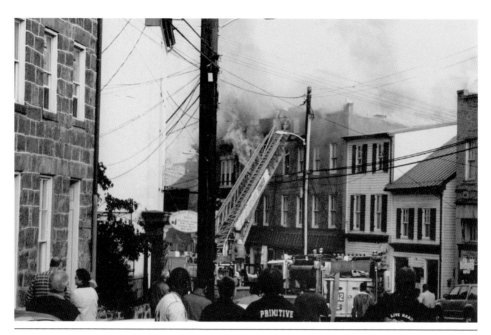

On Tuesday, November 9, 1999, fire again severely damaged Main Street. This time, a cigarette carelessly tossed behind the Main Street Blues Restaurant developed into a six-alarm fire that raged through six buildings. One of the problems faced by the firefighters was the limited access— Main Street is narrow and a stream runs behind the buildings. Other businesses affected include Rugs to Riches, Legends, the Nature Nook, and Spring House Designs. The new building houses Shoemaker Country.

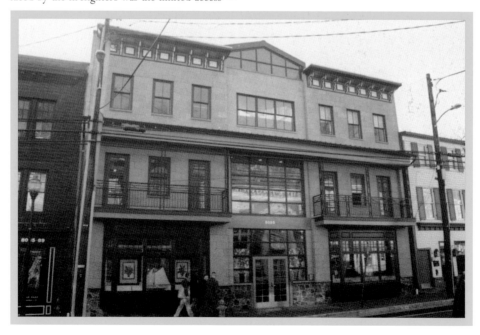

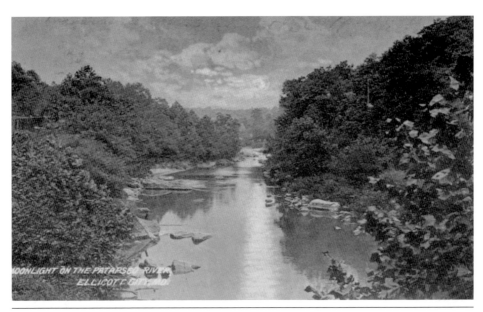

In his book, *The Patapsco River Valley*, Henry Sharp calls the area "the cradle of the industrial revolution in Maryland." The Patapsco River was for a long time an important source of power for the various mills built along its banks. Much of the path of the first 13 miles of the first railroad in America follows along its banks. Today the river is valued mainly for its beauty and its recreational opportunities.

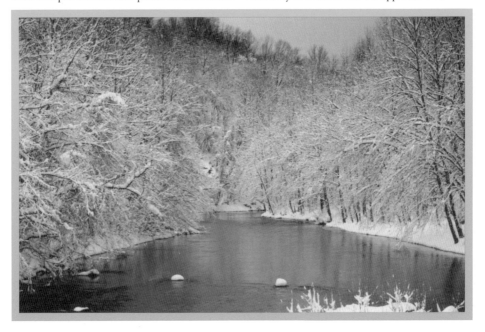

FIRES, FLOODS, AND FORCES OF NATURE

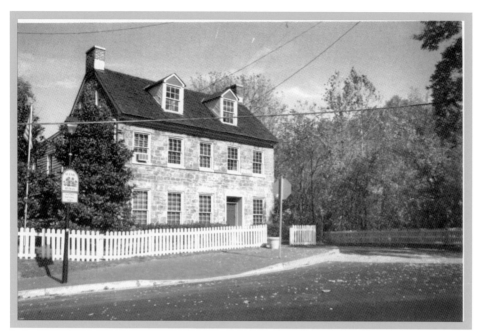

This native granite building, often referred to as Radcliff's Emporium, stands between the railroad bridge and the Patapsco River and is considered one of the oldest buildings in town, built around 1780 and surviving the flood of 1868. It has been a mill hand's home, a general store, market, church, hardware store, and Appalachian Outfitters. It was damaged during Tropical Storm Agnes and restored in the 1980s. It is currently the office of Zip Publishing. (Then image courtesy of Charlotte Holland; now image courtesy of Scott Habicht.)

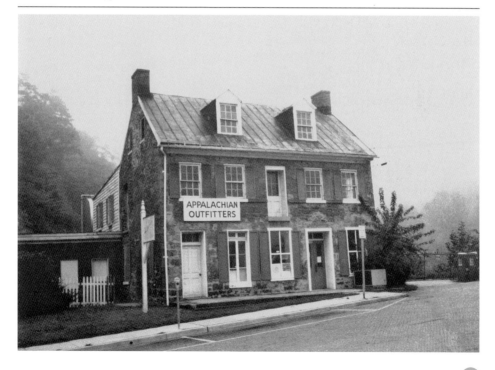

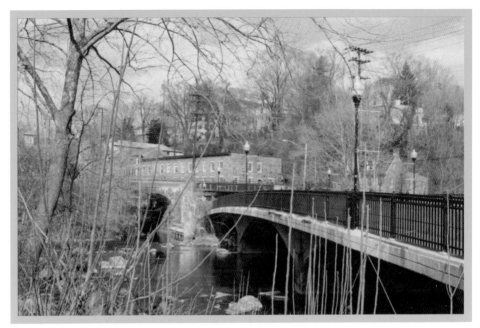

On June 21 and 22, 1972, Tropical Storm Agnes—the biggest natural disaster in Howard County history—caused extensive flooding. A flood marker next to the Ellicott City B&O Railroad Station Museum shows that the area was under 10 feet of water at one point. It was a town turning point, with people deciding to stay, and after shoveling out mountains of mud and debris, the community rebuilt—with the possibility of another flood always present. (Then image courtesy of Charles Wagandt.)

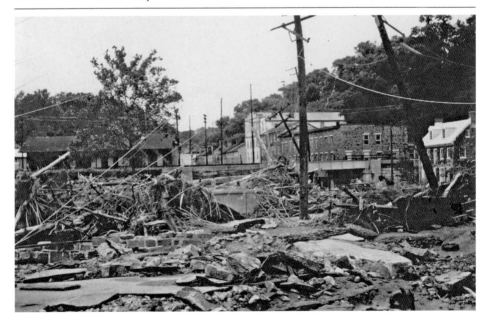

FIRES, FLOODS, AND FORCES OF NATURE

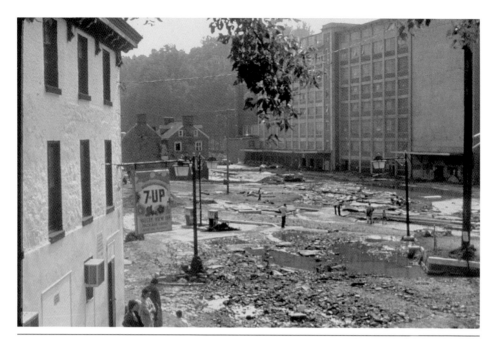

Just three short years after the devastation of Tropical Storm Agnes, the residents and shop owners of Ellicott City were again faced with raging floodwaters when Hurricane Eloise struck in the fall of 1975. Once again, people had to be evacuated from their homes and businesses, and once again, a daunting clean-up effort was required. Today a sophisticated monitoring system is in place to provide the earliest possible warning of eminent flooding. (Then image courtesy of Bob Miller.)

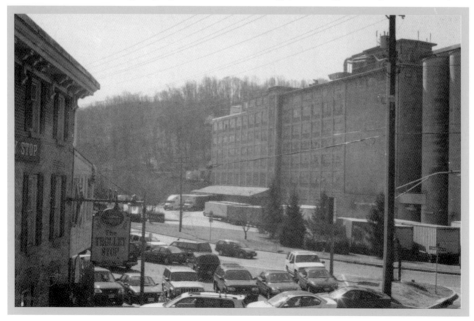

On Palm Sunday, at the end of March 1942, the Baltimore-Washington metropolitan area was hit by a most unusual snowstorm. Legendary to this day and not repeated, snow blanketed the Ellicott City area and made travel challenging. In 2006, Palm Sunday looked a lot more like we have come to expect, with green grass, budding trees, and pedestrians out and about in their light jackets. (Then image courtesy of Betty Yates Jacobs.)

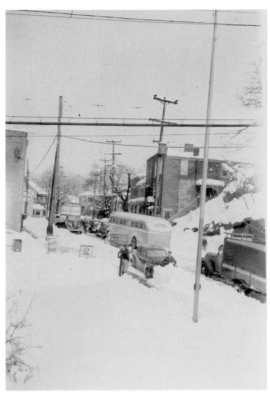

FIRES, FLOODS, AND FORCES OF NATURE

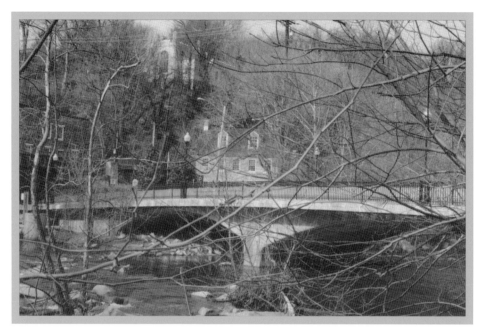

The Patapsco River Bridge spans a seemingly tranquil body of water that marks the boundary between Howard and Baltimore Counties. Regularly residents mark the water's rise during storms, fearful that the next disaster is imminent. Despite the constant threat, the knowledge that Ellicott City has persevered through more than two centuries of fires, floods, and other forces of nature reassures us that we will continue as a viable community for centuries to come.

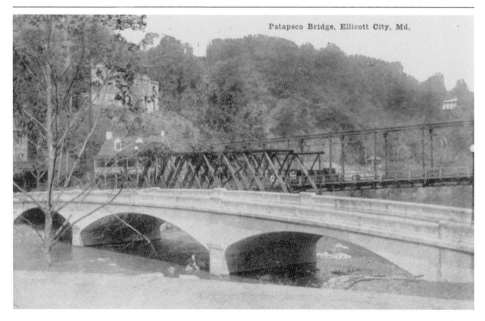

Patapsco Bridge, Ellicott City, Md.

ACROSS AMERICA, PEOPLE ARE DISCOVERING SOMETHING WONDERFUL. *THEIR HERITAGE.*

Arcadia Publishing is the leading local history publisher in the United States. With more than 3,000 titles in print and hundreds of new titles released every year, Arcadia has extensive specialized experience chronicling the history of communities and celebrating America's hidden stories, bringing to life the people, places, and events from the past. To discover the history of other communities across the nation, please visit:

www.arcadiapublishing.com

Customized search tools allow you to find regional history books about the town where you grew up, the cities where your friends and family live, the town where your parents met, or even that retirement spot you've been dreaming about.